Art Deco

Masterpieces of Art

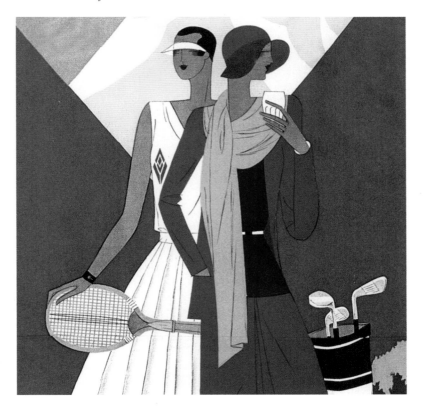

Publisher and Creative Director: Nick Wells
Commissioning Editor: Polly Prior
Senior Project Editor: Catherine Taylor
Picture Research: Polly Prior and Catherine Taylor
Art Director: Mike Spender
Layout Design: Federica Ciaravella
Copy Editor: Ramona Lamport
Proofreader: Dawn Laker
Indexer: Helen Snaith

Dedicated to Carol Ward and Dennis Wardleworth, whose enthusiasm for Art Deco has been a great source of inspiration.

FLAME TREE PUBLISHING
6 Melbray Mews
Fulham, London SW6 3NS
United Kingdom

www.flametreepublishing.com

First published 2018

22 24 26 25 23
3 5 7 9 10 8 6 4 2

© 2018 Flame Tree Publishing Ltd

Front cover: *Tour Eiffel*, 1926, by Robert Delaunay (1885-1941),
Courtesy of Musee d'Art Moderne de la Ville de Paris, Paris, France/Universal History Archive/UIG/Bridgeman Images.

Back cover: *Bather, c.* 1925, by René Vincent (1879–1936).
Courtesy of Chateau Musée, Dieppe, France/Bridgeman Images.

A CIP record for this book is available from the British Library upon request

Image Credits: Courtesy of **Bridgeman Images:** 1 & 78 PVDE; 3 & 118 Bibliotheque des Arts Decoratifs, Paris, France/Archives Charmet; 4 & 61 Musée De La Publicité, Paris, France/ Mondadori Portfolio/Giorgio Lotti; 7 & 99, 108 Private Collection/Prismatic Pictures; 9l & 64, 12 & 56, 30, 36, 50, 52, 74, 75, 92, 93, 117, 120 Private Collection/Photo © Christie's Images; 10 & 28 & 41 Musee d'Art Moderne de la Ville de Paris, Paris, France/Universal History Archive/UIG; 14br & 107 © British Library Board. All Rights Reserved; 19 & 67 Granger; 33 Musee de l'Orangerie, Paris, France/© ADAGP, Paris and DACS, London 2018; 34, 40 Private Collection/Photo © Christie's Images/© Tamara Art Heritage/ADAGP, Paris and DACS London 2018; 37 De Agostini Picture Library/G. Dagli Orti/© ADAGP, Paris and DACS, London 2018; 38 Chateau Musee, Dieppe, France; 43 Private Collection/© Christie's Images/© ADAGP, Paris and DACS, London 2018; 44 Brooklyn Museum of Art, New York, USA; 47 Musee des Beaux-Arts, Orleans, France/© Tamara Art Heritage/ADAGP, Paris and DACS London 2018; 48, 98, 106 Private Collection/The Stapleton Collection/© ADAGP, Paris and DACS, London 2018; 53, 95 Private Collection/Photo © Christie's Images/© ADAGP, Paris and DACS, London 2018; 55 Detroit Institute of Arts, USA; 57 The Art Institute of Chicago/Solomon Byron Smith and Margaret Fisher funds/© Heirs of Aaron Douglas/DACS, London/VAGA, NY 2018; 63 Universal History Archive/UIG/© DACS 2018; 65 PVDE/© ADAGP, Paris and DACS, London 2018; 66, 73, 103 Granger/© ADAGP, Paris and DACS, London 2018; 72 Private Collection/Peter Newark American Pictures/© ADAGP, Paris and DACS, London 2018; 77 Private Collection/© Ackermann Kunstverlag; 79 Private Collection/© GraphicaArtis; 84 Private Collection; 94 Private Collection/Photo © Christie's Images/© Munetsugu Satomi; 96 & 97 & 121, 109 British Library, London, UK/© British Library Board. All Rights Reserved; 105, 111, 112, 113, 124 Private Collection/The Stapleton Collection; 116 Private Collection/Photo © Christie's Images/© Sevenarts Ltd; 122, 125 Private Collection/Archives Charmet. © **Rex/Shutterstock:** 6 & 68, 81, 104 Kharbine-Tapabor; 14tl & 31 & 128 Granger; 62 Granger/© Sevenarts Ltd; 89 CCl/© ADAGP, Paris and DACS, London 2018. Pinterest/ Angelica Cassia Longina: 8. Courtesy of Wikimedia Commons: 9r **Heinz Thate/Hersteller nicht bekannt**/CC-BY-3.0; 11 User:**thisisbossi**/CC BY-SA-2.0; 15 **Vincent Arel**/ CC-BY-3.0; 16 **AlfvanBeem**/CC0-1.0; 17 **Steve Cadman**/CC-BY-SA-2.0; 18tl **An Siarach**/Public Domain; 21t © **A.Savin**/Copyleft: Free Art License; 21b **Pyzhou**/GFDL-1.2; 23 **Sailko**/CC-BY-3.0; 24br **Phillip Capper**/CC-BY-2.0; 24tl **Adam Jones**, Ph.D./CC-BY-3.0; 25 **Coldcreation**/CC-BY-3.0; 26 **Tony Hisgett**/CC-BY-2.0. Courtesy of **Akg-images:** 13 & 80 Fototeca Gilardi/© DACS 2018; 32 Album/Oronoz/© DACS 2018; 42 Cameraphoto; 49 Courtesy of the Dodo Estate; 91 Pictures from History; 115 Courtesy of THAYAHT & RAM Archive, Florence, Italy; 119 Collection Magnard/© Sevenarts Ltd. Courtesy of **Shutterstock.com** and © the following: 18mr DutchScenery; 22 Urban Napflin. Courtesy of **Getty Images** and the following: 20 & 123 Eduardo Garcia Benito/Conde Nast Collection; 27 & 71 David Pollack/Corbis Historical; 58 & 76, 86 & 87 National Motor Museum/Heritage Images/Hulton Archive; 90 Swim Ink 2, LLC/ Corbis Historical; 100 Universal History Archive/Universal Images Group; 102 Helen Dryden/Conde Nast Collection; 114 DEA/G. DAGLI ORTI/De Agostini. Courtesy of **The Metropolitan Museum of Art**, New York/Gift of Peter M. Brant, 1974: 46. **TM. & © MOURON. CASSANDRE. Lic 2018-26-04-05 www.cassandre.fr:** 60, 70, 88.

ISBN 978-1-80417-335-0

Printed in China I Created, Developed & Produced in the United Kingdom

Art Deco

Masterpieces of Art

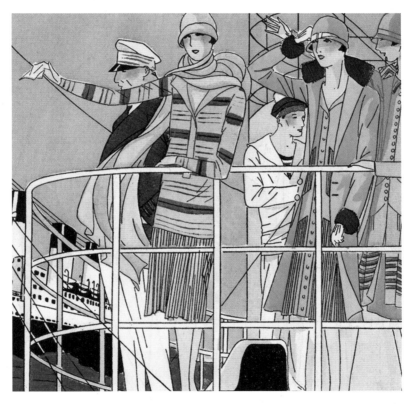

Janet Stiles Tyson

FLAME TREE
PUBLISHING

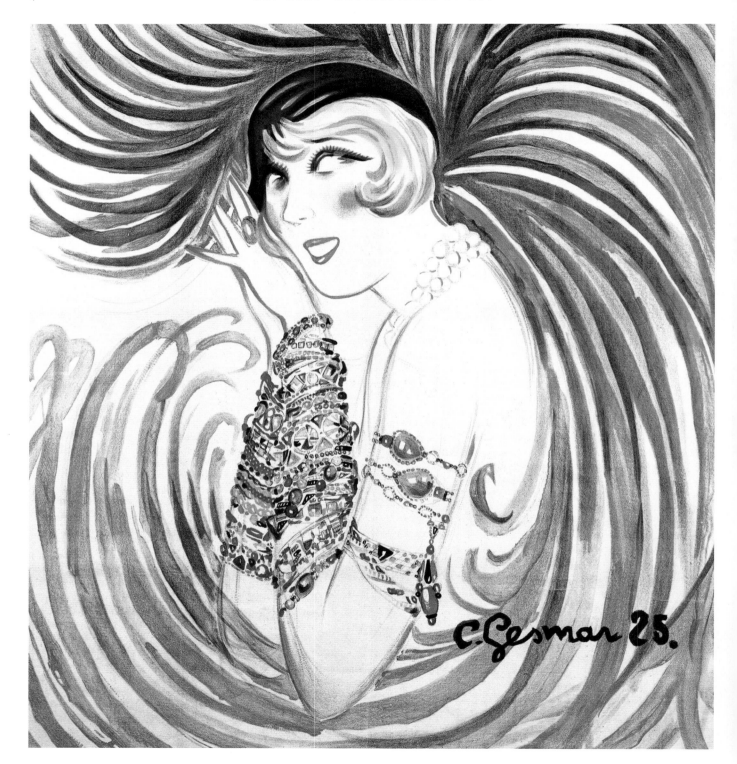

Contents

Art Deco: In With The New

Art Deco is a form of modern design that was applied to an extraordinarily broad range of items, from dresses to toasters to architecture to posters. British art historian Bevis Hillier, who coined the term in his 1968 book *Art Deco of the 20s and 30s*, called it a total style because it was so pervasive. However, it was more than that. Especially during the interwar period, it also symbolized social, technological, artistic and economic changes that, in turn, fed Deco aesthetics and made it influential and widely available.

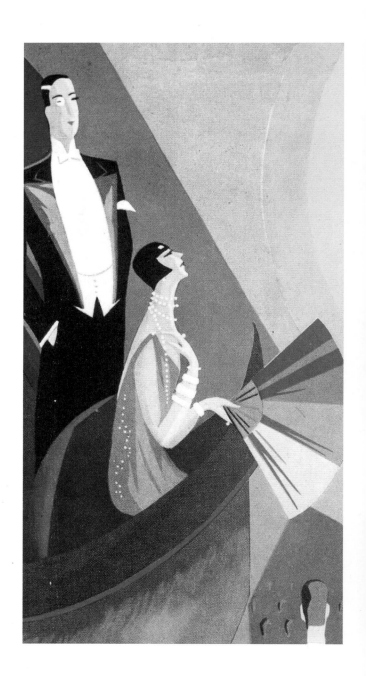

The roots of Art Deco reach back to around 1910 and to France. Its full flowering occurred with an exposition in 1925 that would inspire the name by which it is popularly known. At that time, however, the elements automatically thought of as 'Deco' – taut curves, lively zigzags, speed lines and an eclectic use of materials – were classified as elements of 'Style Moderne', and all of that witty elegance was originally aimed at an exclusive, elite clientele. With the crash of global markets in 1929, Style Moderne became Streamline Moderne. It still featured some ornamentation, but was overall sleeker and more sober, and was an integral aspect of design culture into the years of the Second World War. The 1939 New York World's Fair is often cited as Deco's last hurrah. The War then ushered in the ruthlessly stripped-down aesthetic of International Modernism. Inspired by Bauhaus philosophies of design, Modernism held sway for some 25 years until it, too, was carried away.

The ferment of the 1960s saw seemingly all norms questioned and authority challenged to the tipping point. And Style Moderne – at once jazzy and practical, audacious and understated – enjoyed what could be called its second coming. Re-christened 'Art Deco', it became popular once again, the hidden treasure of flea markets and, increasingly, the stuff of museum collections.

Moderne/Deco

This book uses both terms interchangeably to identify a visual style inspired by commercial and national needs, and oriented towards sales to consumers. It is divided into two sections: an introductory text and a pictorial section which is divided into three sections, and which represents Art Deco in its two-dimensional forms addressing fine art, posters and illustrations. However, because so much of Art Deco was expressed in terms of architecture and smaller-scale material goods, the writing here addresses a wide range of three-dimensional design forms, as well as the materials they incorporated.

The loose chronology employed will occasionally loop around in order to address specific topics, such as technological and social developments relating to Art Deco. It begins in France *c.* 1910 and addresses the cultural and economic forces that launched Style Moderne. It then proceeds to the 1925 Exposition in Paris that brought Art Deco to the world's attention. After that, it examines the technological advances that created a context for some of the cultural forms associated with Deco, ranging from the expanded availability of electricity to the manufacturing of new plastics. It addresses cultural and social shifts brought on by the First World War and the Great Depression, including greater freedoms for women in the Western world, and freedom achieved by thousands of Afro-Americans who left the United States for France.

Lastly, it will look at how Style Moderne was adopted and adapted by nations and cultures around the world – for the most part in the form of architecture. As an epilogue of sorts, it also briefly explores the demise of Deco and its revival.

Beginnings

As noted, Art Deco originated in France, largely in Paris, around 1910. It was a time when French designers and craftsmen were eager to recover their primacy in production of innovative luxury goods – an arena in which they had excelled since at least the eighteenth century, but one in which Austria and Germany had come to be equals, if not leaders. Of course, France still was the leader in avant-garde fine art, owing to such artists as the Cubists Pablo Picasso (1881–1973) and Georges Braque

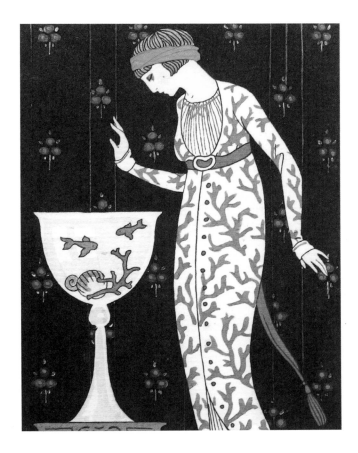

(1882–1963); the Fauve painter, Henri Matisse (1869–1954); and Fernand Léger (1881–1955) – whose figures appeared to be assembled from sleek, tubular machine parts. However, French design was still associated with an Art Nouveau that no longer seemed especially artful or particularly new.

In the meantime, German and Austrian advances, as noted above, had fired French competitive anxiety. Products of the Deutscher Werkbund and the Wiener Werkstätte came to be recognized as fresh, functional, adaptable, well made and aesthetically pleasing. In other words, notably and progressively suited to daily life. Even an American, the architect Frank Lloyd Wright (1867–1959), had published drawings so brilliantly modern that they were pored over by Werkbund designer Peter Behrens (1868–1940), Le Corbusier (1887–1965) and Ludwig Mies van der Rohe (1886–1969), among others.

Some French designers had begun to achieve international reputations, most notably Emile-Jacques Ruhlmann (1879–1933). Widely considered Art Deco's pre-eminent luxury designer, Ruhlmann began by working in his family's business of interior decoration. By the 1920s, he was the most prestigious, in-demand designer of furniture and interiors of his day. In 1923, New York's Metropolitan Museum of Art purchased its first Ruhlmann piece – his deceptively simple Tibbattant Desk – of the more than 40 Ruhlmann works, in two- and three-dimensions, that it now owns. His 'Doucet' chairs (*see* below), with their simple lines, Macassar ebony veneers and mother-of-pearl inlay, were produced *c.* 1912 for couturier Jacques Doucet, who replaced his home's eighteenth-century furnishings with Style Moderne. Other, forward-thinking individuals included furniture and interior designer Francis Jourdain (1876–1958); Antoine Bourdelle (1861–1929), a sculptor of monuments and decorative works; and painter Sonia Delaunay (1885–1979), who had branched into fabric and clothing design. They were producing works for French collectors, but they wanted an event that would bring their products before the world.

International expositions were popular and successful ways for designers and manufacturers to connect directly to both the public and the market. Between 1918 and 1939, some 21 expos had been mounted in France, Britain and Belgium. They introduced and promoted the intertwined interests of commerce and governments. After a delay, owing to the First World War and the ordeal of post-war recovery, the desired French design showcase was presented. The war had unleashed a convulsive break with the past. With no way back, people sought to move towards a modern future. Economic recovery played a crucial role in moving towards that future and, for French planners, this recovery became another motive for mounting their expo.

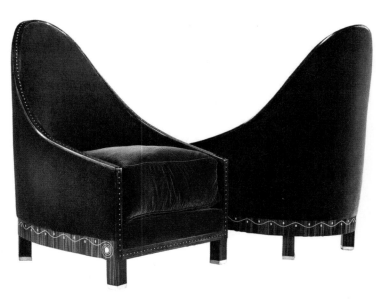

An Art Deco Overview

In 1925, the 'Exposition International des Arts Décoratifs et Industriels Modernes' was presented in Paris, setting the stage for Style Moderne to become a global phenomenon (*see* page 64). It ran for six months and attracted 16 million visitors, including journalists, artists and designers, as well as representatives of governmental and private commercial interests. Of the two broad iterations of Style Moderne noted above, the Exposition presented that which involved considerable visual complexity and novelty, as well as incorporation of expensive materials. This was the Style Moderne of worldly sophisticates, of maharajas who built Deco mansions and furnished every room with designs by Ruhlmann and Eileen Gray (1878–1976).

This early expression of Style Moderne was notably voracious with respect to its sources of inspiration. Fair game included the geometric shapes inspired by Cubism and other avant-garde art forms – as well as by the sleek lines of modern industrial machinery that had influenced that same avant-garde. Flora and fauna were abundantly employed, as were motifs from ancient or 'primitive' non-Western cultures. Thus, ancient Mesoamerican, Chinese, Japanese, Egyptian, Assyrian and sub-Saharan African symbols and patterns found their way into decoration of buildings, furniture, jewellery and fabrics.

Unlike its predecessors – Art Nouveau and British Arts and Crafts – Art Deco was not based on an ideology. It was not prescriptive, it had no axe to grind and had no governing set of rules. As such, it could be adapted to local aesthetics and interests anywhere in the world. Nor did consumers need to cultivate an informed appreciation of Deco's indiscriminate stylistic mash-ups. It was there to be accepted at face value and

enjoyed. Rooted in pragmatism, Style Moderne was focused on selling products that consumers could enjoy. It was not an exclusively urban phenomenon, but its aesthetic reflected the fast-paced culture of city life. It was also emphatically modern, with a preponderance of geometry, sleek surfaces and hard edges on even the organic motifs, for example in the silver coffee and tea service shown below, designed by Jean-Emile Puiforcat (1897–1945) in 1925. Material for knobs and handle-insets was varied and included ebony, ivory and stone. It appears that marble was used as well.

After the economic collapse of 1929, the second manifestation of Style Moderne fitted the tenor of those more sober times. It also coincided with intense interest in machine aesthetics, including streamlining. Surfaces became expansively flat, with relatively few interruptions.

There was less verticality and fewer zigzags, and greater emphasis on the horizontal. To an extent, the new aesthetic communicated restraint and seriousness, as befitting the hardship faced by so many cities and nations, but it also reflected the influence of advances in transportation engineering.

Wind-tunnel tests had demonstrated the link between sleek form and greater speed in cars, ships and aeroplanes. This inspired designers of objects that might not have required streamlining, but who wanted

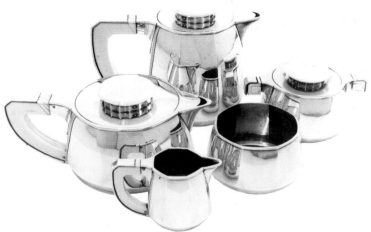

to evoke modern tropes of mobility, speed and travel. The pencil-sharpener designed by Raymond Loewy (1893–1986) is probably the most notorious example, but the form of radio sets, adding machines, refrigerators and cigarette lighters also became streamlined for reasons of fashion rather than function.

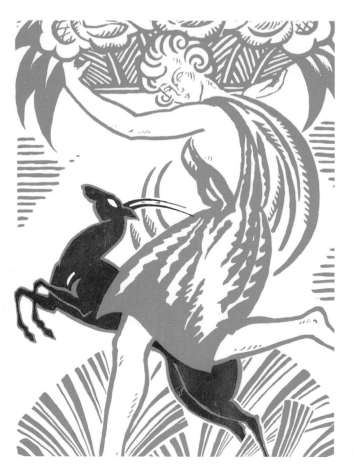

Arguably the most irrelevant use of streamlining came with its application to building design. To evoke the sense of a steamship's gleaming hull, architects designed buildings that most often were clad in white-painted stucco. Features included speed lines, balconies that were curved like the stern of a luxury liner, railings that would be found on ships' bridges and porthole-shaped windows. However, all was not a matter of style over substance. Such pared-down design also often featured expansive windows that let in sunlight and fresh air – in line with modern ideas of good health and unencumbered movement.

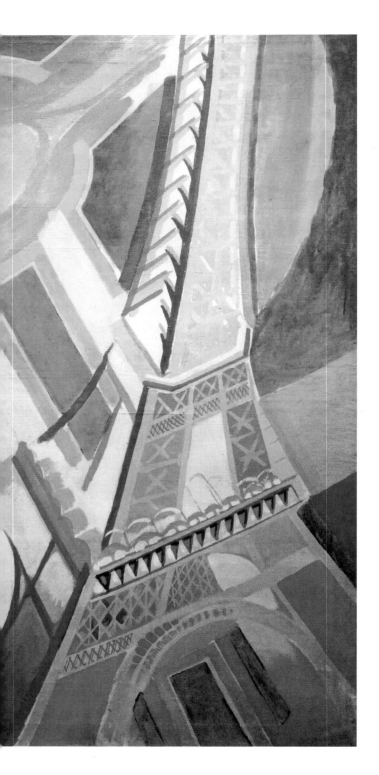

The 1925 Exposition

The *Exposition Internationale* opened in April 1925, on the Left and Right Banks of the Seine. Admittedly, it was not quite international: few non-Western countries took part and, even then, Germany and the US were absent. Invited belatedly, Germany was unable to organize a suitable display. The United States – according to then-Secretary of Commerce Herbert Hoover (1874–1964) – did not have a sufficiently modern gathering of goods to present. However, even though it did not participate, the government sent more than 80 delegates to the exposition, who were captivated by designs for living that were in sync with American optimism and American wealth.

As would have been immensely gratifying for expo organizers, the French presentations generated considerable excitement, along with some criticism of their excessive luxury. Parisian pavilions were located on the Left Bank, and upon the Pont Alexandre III, which linked the two sides of the river. Provincial French displays were on the Right Bank, as were most of the foreign presentations. French displays for designers and retailers, including the great department stores, emphasized *haute couture* and accessories, furniture and decorative objects, and interior design. The Pavillon de l'Esprit Nouveau, organized by architect Le Corbusier, offered some recognition to lower-cost, mass-produced furnishings in an open, healthful setting, but expensive novelty prevailed.

The French displays reflected a mix of cultural sources, including the sometimes-bizarre sets and costumes that Léon Bakst (1866–1924) had designed for the Ballets Russes (*see* page 100). Colours and patterns harkened to folkloric and peasant sources, creating some overlap with the colourful works by Matisse and Delauney. Perhaps the greatest impact of these vivid sources was on the design of jewellery, which began incorporating intensely coloured gems such as emeralds from Colombia. This also was a point when the trim, angular baguette cut for gems became fashionable, such as the Cartier necklace shown on the right which highlights a 168-carat Colombian emerald, set in platinum with diamonds and rather smaller emeralds. It was a wedding gift from financier Clarence Mackay to his bride, the former diva of the New York Metropolitan Opera Anna Case, in 1931.

The athleticism of the Ballets Russes performers was another inspiration. The freedom of movement embodied by Vaslav Nijinsky (1889–1950), Tamara Karsavina (1885–1978) and other dancers was echoed by harem pants and drop-waist chemises from couturier Paul Poiret (1879–1944). These relaxed garments, in turn, supported the body awareness promoted by Francis Jourdain's Physical Culture Room. While the French took up about 75 per cent of the exposition, other participants made do with one pavilion each. The Netherlands pavilion featured a triangular brick façade that seemed to mix the peaked silhouettes of traditional Dutch urban houses with native structures from its Asian colonies. That said, its interior reflected *De Stijl* modernity. The Russians presented a determined mix of stark, revolutionary geometry and traditional peasant motifs. A simple, sophisticated design by Josef Hoffmann (1870–1956) housed the display for Austria, so recently released from Habsburg rule. The building's architecture and the objects it contained revealed an aesthetic akin to the French vision of refined innovation.

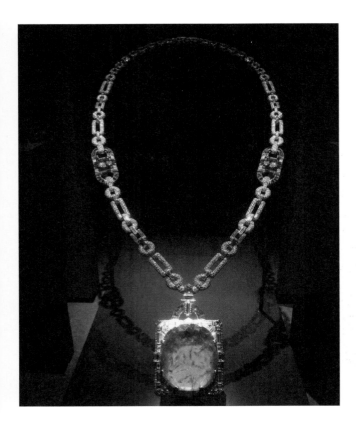

Architecture of the British pavilion, designed by J.M. Easton (1889–1975) and Howard Robertson (1888–1963), exemplified Style Moderne with an Orientalist twist. Even so, photographs displayed within, which depicted current British architecture, spoke of tradition and the above-noted disdain of pretentious luxury. Even the *Pièta* by William Reid Dick (1879–1961), which received a gold medal for sculpture, was a traditional form, albeit simplified and more fluid in design than traditional portrayals of the subject.

For Poland, the exposition had particular symbolic meaning. After centuries of exploitation and partition by neighbouring empires and states, the country was granted independence and unification under articles drawn up after the First World War. Participating as a nation in Paris in 1925 gave Poland a chance to express a national identity that honoured tradition and looked forward to the future. Its pavilion was celebrated for its coherent presentation of folkloric tapestries and furnishings, set in a series of simple, contemporary rooms.

Style Moderne in France and Beyond

Extensive publicity for the 1925 Exposition helped spread news of Style Moderne to far-flung populations. Industrial and retail interests, who might previously have underestimated its vibrant appeal and adaptability, began planning ways to develop markets for new products in the modern style. Art Deco's pastiche of patterns and motifs could exude refinement or exuberance, and the extent to which designs could be scaled up or scaled down underscored its versatility and potential appeal. Panels of compressed geometric and foliate motifs – carved in limestone or cast in bronze – could adorn a skyscraper and signal that the business housed within was progressive and prosperous. However, that same dense mosaic of shapes scaled down for use in jewellery, picked out in diamonds and rubies and set in platinum, left no doubt as to the wearer's privileged chic.

In France, emphasis on luxury extended beyond Parisian interiors to exclusive resorts that used sophisticated advertising to attract rich tourists. It also inspired the design and construction of one of the most fabled ocean liners of all time, the SS *Normandie*. She was a concise embodiment of Bevis Hillier's 'total style' – powerful, fast and beautiful.

She was launched in 1932, seven years after the Paris Expo, and might be considered France's second and last great statement of luxurious innovation – the first being the Expo itself. Of the graphic designers who created publicity for the luxury liner, the most memorable is A.M. Cassandre (1901–68), whose poster offers a vertiginous view of the ship's prow, with the name 'Normandie' spelled out in block letters across the bottom edge.

For the ship herself, many of the designers who had made the 1925 Exposition memorable were contracted to contribute to the *Normandie*'s interiors and furnishings. René Lalique (1860–1945) created 12 illuminated glass columns and 38 similarly brilliant pilasters for the First Class dining room. Illustrator and painter Jean Dupas (1882–1964) worked with technicians to create extraordinary murals evoking nautical history and mythology (*see* page 56). The media they employed included gold, silver and palladium leaf, black paint and massive sheets of glass. Jean Puiforcat (1897–1945) designed silver flatware and holloware for the table settings.

Outside of France, Style Moderne was adapted to the social and cultural needs and aspirations of individuals and nations around the world. The broadest range of applications was almost certainly in the United States, both prior to and after the Wall Street Crash. Style Moderne had not been developed with architecture in mind, but in the US it seemed the

logical style for skyscrapers that would symbolize the nation's modernity, wealth, power and optimism to itself and to the world (*see* page 40). Other nations quickly adopted the form, almost as quickly as they embraced that other American Deco icon, the Hollywood movie.

New Freedoms

Regardless of where it was adopted, Art Deco symbolized and embodied change – social and cultural, but also a change in modes of commerce. As noted, the dynamism expressed in this wide range of design applications predated both the First World War and the 1925 Exposition. However, after the conflict was over and nations had begun to recover, Style Moderne came into its own. In spite of – or perhaps in reaction against – the war's devastation, many of the changes it had wrought were played out on an Art Deco stage.

This was especially the case for the women who had carried out men's work while the latter went to war. They had laboured on assembly lines and had made decisions for their families and themselves. They had arrived at a much clearer sense of strength and potential, and wanted further access to realms that had been closed to them prior to the horrific conflict – at home, socially, in the work place, in the market place and in politics. In 1918, some British women won the right to vote. Two years later, American women obtained suffrage.

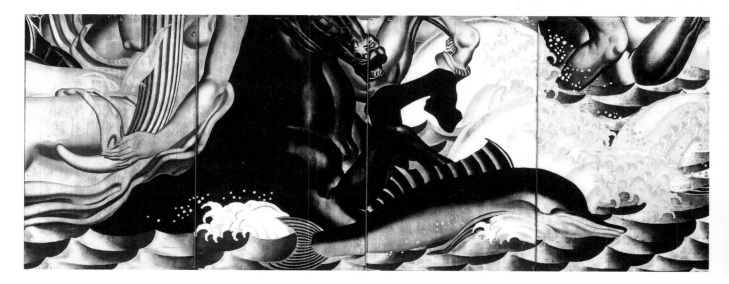

However, countless cultural barriers remained. Many, as history has borne out, persist and pose serious, even deadly challenges. However, during the era examined here, there were ways in which a woman could chip away at oppression and even have some fun. To a great extent, simply being in public would suffice. Being seen in public in a comfortable dress that did not require a corset, or flourishing a cigarette, were other ways of defying social constraints (*see* page 80). A woman might bob her hair and, thus, appal her elders. Short hair was more than a statement, however; it fitted in with the more athletic forms of recreation in which women were beginning to partake. And it would not become hopelessly tangled by the wind when she got behind the wheel of her car. That said, such gestures were accompanied by acts of material consumption: shorter, straight dresses; a sleek case for those cigarettes; a cloche hat for that short hair and a stylish hatpin for that hat; a snazzy, mirrored compact that facilitated public application of cosmetics.

Art Deco and Social Change

The effect of women's widespread appearance in public was noted by the *Illustrated London News* in 1926. It reported that the transformation of sophisticated and proper social venues into 'recognised places of amusement' was 'largely due, no doubt, to the emancipation of woman, who has won her right to share with man his frivolities as well as his professions'. And such frivolities were regularly pursued in the Art Deco environs that even smaller cities managed to develop. In London, by no means a small city, Art Deco had had a relatively modest impact in terms of architecture. However, it did have Claridge's – with new public spaces designed by Basil Ionides (1884–1950) and Oswald Milne (1881–1968) – and the Kit Kat Club. These stages were occupied by a small army of affluent, often aristocratic, young men and women who came of age during the First World War, and seemed excessively intent upon forgetting the destruction it had brought to their families. Not unlike their contemporaries elsewhere in Europe and the United States, they were drawn to a privileged version of urban Bohemian life. They pursued pleasure to the tune of jazz music, and they consumed, enacted and produced literary and visual representations of their own heady lifestyles.

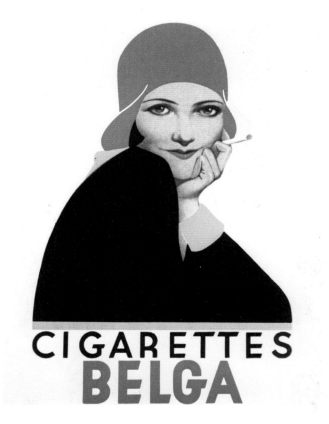

Sometimes called the 'Bright Young Things', their numbers included photographer, painter and stage- and costume-designer Cecil Beaton (1904–80) and poet Edward James (1907–84), the noted patron of surrealist art. Artists' model Iris Tree (1897–1968) bobbed her hair, and her coiffure was daringly immortalized as a gleaming bronze helmet by sculptor Jacob Epstein (1880–1959). Evelyn Waugh (1903–66), something of a participant-observer, wrote novels that dissected the cultural milieu of which he was part. Not all were English: the American dancer, Adele Astaire (1896–1981), came to London to perform and ended up retiring to marry Lord Charles Cavendish (1905–44). Adele's younger brother, Fred, will be considered on page 20.

In New York, Chicago and Detroit, among other American cities, Prohibition encouraged fashionable men and women to flout the law and frequent speakeasies — a source of forbidden pleasure that disappeared with Franklin D. Roosevelt's repeal of Prohibition. The most conspicuous prop for their romps were skyscrapers, whose upper

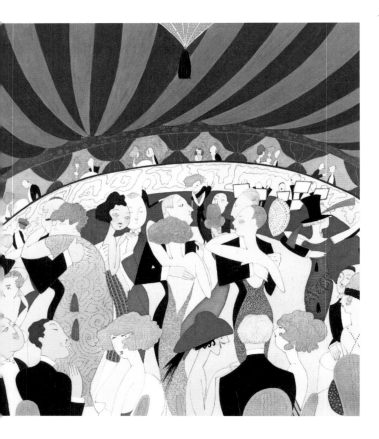

floors were 'set back' to allow sunlight to reach the streets below. What began as a zoning requirement became part of the zigzag outline so integral to Style Moderne. In Harlem, New York, another sort of cultural shift was occurring; one that saw young white people trooping to clubs in a neighbourhood that had come to be almost exclusively populated by black men, women and children (*see* page 57).

Ironically, as European-American youth went 'slumming' in Harlem and other urban neighbourhoods, hundreds of young Afro-Americans were travelling to the great cultural capital of Europe, Paris, seeking respite from the racism at home. Paris, in the meantime, was energized not only by Style Moderne but by jazz as well. A melange of primarily African and Afro-American rhythmic and tonal tropes, jazz irresistibly pulled people out of their chairs and on to the floor. The *Charleston* and the *Black Bottom* were extravagant, semi-comedic dances that had men and women swing their arms, kick up their legs and wiggle

their derrieres. Invented by black Americans, the music and the dances were enjoyed by white men and women too, but rarely at the same time in the same clubs.

The 1910s and 1920s saw a slight increase in the degree of communication between races in the United States, and provided some positive visibility for celebrated black performers. However, performers such as dancer Josephine Baker (1906–75) sought more than scraps of respect and fame. Travelling to France with a group of musicians, singers and dancers who had gained recognition in New York, Baker held court at the Folies Bergère. An astute businesswoman and innovative entertainer, she devised comic-erotic dances that amazed and delighted her audiences. Graphic works by the white French artist Paul Colin (1892–1985) promoted Baker's 'La Revue Nègre' (*see* page 65), creating a brilliant synthesis of visual style and subject matter. Native Parisians, captivated by Afro-American and African culture, generally welcomed the black American émigrés.

Other successful ex-patriot Afro-American artists included sculptors Richmond Barthe (1901–89) and Nathaniel Choate (1899–1965),

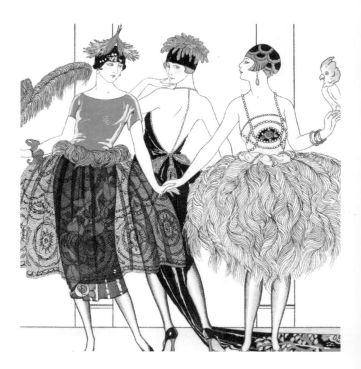

both of whom explored African subjects. Although traditional, Barthe's portrait busts and figures were simplified in ways that allowed them to fit into Moderne decor. Choate's figures of humans and animals, however, often exhibited distinctly Deco blendings of angles, curves and sharp edges – which in turn echoed the forms of native African sculpture from cultures of the Ivory Coast and the Sudan. Collected by members of the city's artistic avant-garde, African artefacts were among the many ethnographic sources of motifs prized by Art Deco designers.

New Technologies

However, Style Moderne was more than a mosaic of disparate motifs. It also accommodated, even required, innovation in materials in order to bring those motifs into dramatic realization. Traditional materials such as ebony, marble, glass and ivory were used in new ways and in unprecedented combinations. Freshly minted materials – often mingled with the old – included various plastics and metal alloys.

The rise of Art Deco coincided with the dawning of a golden age of plastics, including Bakelite, celluloid and galalith – all of which were used for items ranging from radio knobs to buttons on dresses. Applied to jewellery and decorative objects, plastics made possible inexpensive reproduction of the lacquer, ivory and tortoiseshell used in luxury Art Deco objects. Bakelite, in particular, could be carved so that the saturated colours it accepted gave pieces a rich, sculptural appearance. The legendary couturier Coco Chanel (*see page 125*) brought Bakelite costume jewellery into her accessories collections in the mid-1920s.

Monel, a nickel-and-copper alloy created in 1901, was used to make architectural grilles that would be impervious to corrosion and staining. The Monel grille in Detroit's Guardian Building (*see right*) is a particularly lavish example of Art Deco architectural metal work. Inset with a Tiffany clock, the grille separates the lobby and former banking floor. Completed in 1929, the Guardian's public areas prominently feature diamond motifs, based on Aztec patterning. Monel was used as a white metal when designers sought a muted, lustrous finish rather than the reflective gleam of chrome.

Chrome plating, invented in the 1920s, gave a mirror finish to the metal surfaces of andirons, lamps, ice buckets, toasters and countless other functional and decorative items, as well as to the structural frames of chairs and tables. Perhaps the most public and widely visible use of chrome, however, was vehicular trim, particularly on automobiles. Cars of the 1920s continued to resemble the horseless carriages that preceded them. Most of them – all along the price continuum – were boxy and featured protruding parts. The 1927 Citroën B12 Torpedo – Citroën was a prominent sponsor of, and participant in, the 1925 Exposition – was actually sleeker than many of its peers. It rode high, but its chromed radiator grille was curved back towards the bonnet and its chrome-trimmed windscreen was raked back to create a sense of forward movement. Other components could be chromed as well, including headlamp casings, bumpers and wheel-hub covers.

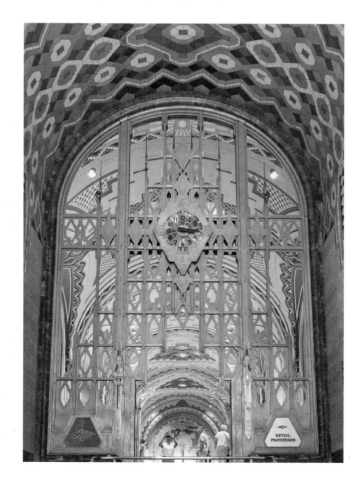

Paradoxically, what is considered the great era of sleek luxury cars did not arrive until after the onset of the Great Depression, at which point low-cost cars also reflected streamlined design. A key automotive design of that decade is the Chrysler 8 Airflow sedan (*see* below), whose grille trim follows the curving front of the bonnet. Horizontal chrome speed lines on the sides of the car further enhance the sense of forward movement, even when it is stationary. In order to create a functionally streamlined American production-line car, Chrysler engineers worked with Orville Wright to test the wind resistance of various prototypes. Abandoning traditional boxy forms, the Airflow 8 was the then-radical result.

Another prominent use of chrome could be seen in radiator caps that took the form of small-scale sculpture. The archetypal example is probably Rolls Royce's 'flying lady', or *Spirit of Ecstasy*, unveiled in 1911. It was sculpted by Charles Sykes (1875–1950), who modelled it on Eleanor Velasco Thornton (1880–1915), whom he believed embodied the fluid grace that he sought.

Other Advances

One of the established, if not ancient, materials used in Style Moderne design was aluminium, which historically had been used for table settings by Napoleon III. At that time, aluminium was so difficult to refine that it was considered more precious than gold and silver. Although processes were developed in the 1880s for extraction of the metal from ore, it was not until hydroelectric power became widely available in the 1930s that extraction was made easier and aluminium gained a practical industrial application. Architectural use of aluminium was somewhat limited, however, due to its tendency to stain when exposed to water.

In 1930, a few years prior to mass industrial production of aluminium, American designer Russel Wright (1904–76) began using it to create oven-to-table dishes, as well as barware and other domestic wares. Wright employed it in spun form, which gave the metal a muted, diffuse sheen that fitted well with Moderne interiors.

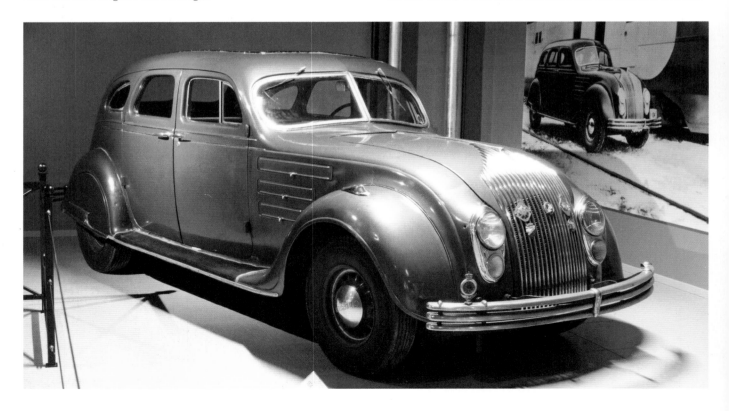

Additionally, in the mid-1930s, the US company Alcoa introduced a stylish line of brass-trimmed aluminium decorative objects, designed by Lurelle Guild (1898–1985).

Clay was another material that lent itself to Moderne styling, and Wright designed subtly hued, widely affordable Moderne dinnerware for Steubenville Pottery. Another wildly successful line of domestic ceramics was Fiestaware, introduced in 1936 by the Homer Laughlin China Company. In order for production to be cost-effective, both brands – along with other mass-produced ceramic wares – relied upon the early-1920s development of continuous-firing tunnel kilns. In Britain, it was Clarice Cliff (1899–1972) who applied rambunctiously colourful Art Deco motifs to mass-produced pottery that freed ceramic tableware from the constraints of tradition.

Glass

The ancient material – dating back as far as the fourth millennium BC – that lent itself to the greatest degree of innovation, however, was glass. Its great physical versatility and aesthetic appeal allowed it to be used in everything from architecture to jewellery. Glass of the Art Deco era was used to create tubes in radio sets, bricks in progressive architecture and the creation of all manner of functional and decorative objects for the home. In tempered or toughened form, glass was used for humble baking dishes. In the 1930s, tempered glass came to be used for automobile windscreens because it would effectively crumble rather than break into knife-like shards. Yet, when cast by Lalique, glass could be illuminated in the form of sculptural lamps and exquisite perfume bottles for Nina Ricci and Coty, as well as figural hood ornaments that had more panache than even Rolls Royce's lady, including 'Victoire', popularly called *Spirit of the Wind*, designed in 1925 for Delage.

A particularly creative use of glass in architecture was the refinement of the so-called glass brick. Gustave Falconnier (1845–1913) developed the first air-tight glass brick in 1886, but the process did not lend itself to cost-effective mass production. That issue was resolved in the 1930s, when the US company Corning-Steuben developed a way of pressure-moulding halves of glass blocks,

which were then fused together. The resulting unit could be used in construction of translucent glass window walls that conducted light but preserved privacy. Glass walls became a key element of Streamline Moderne design.

Pigmented glazing was another important development in Art Deco architectural glass. Vitrolite and Carrara Glass developed the high-strength material for interior walls and exterior cladding. A stunning example of pigmented glass in architectural design is the former *Daily Express* building in London's Fleet Street (*see* above). Dating to 1932, it features several characteristics of Streamline Moderne. In addition to its gleaming expanses of black Vitrolite, it has rounded corners and strip windows, all set off by a grid of chrome-plated trim.

A final, and significant, development in architectural glazing came not through a new formula for glass but a new way of producing metal frames to hold window glass in place. Metal mullions have been used for leaded glass windows for hundreds of years. However, mullions strong enough to support large, heavy expanses of glass were bulky and thick. The problem was solved when Crittall Windows perfected galvanized steel frames that featured 'Fenestra' joints at intersections

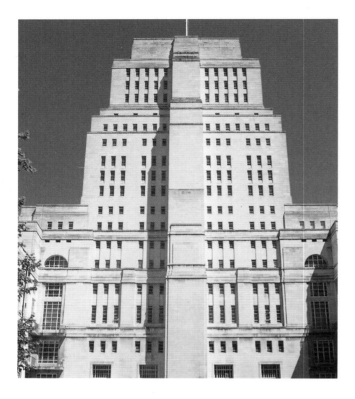

In the United States, such projects as the Roosevelt administration's Tennessee Valley Authority's network of dams provided critically needed jobs during the Great Depression, and improved the lives of countless rural communities and households. Thus the cycle of technological advances, employment, disposable income and creation of new consumer products continued to engage with Art Deco inventiveness.

On the one hand, electrical steam irons, clocks, toasters, rotary fans, tea kettles, space heaters, sewing machines and other mundane appliances made housekeeping that much easier. On the other, they provided new opportunities for the application of Streamline Moderne

of horizontal and vertical members. Significantly stronger than previous window joints, it permitted slimmer mullions that, in turn, let in more light. Crittall Windows were used in all kinds of buildings, regardless of architectural style, but the trim metal frames became synonymous with Streamline Deco structures such as Senate House at the University of London (*see* above), designed by Charles Holden (1875–1960) and occupied from 1936. Sufficiently imposing that Evelyn Waugh called it 'the vast bulk of London University insulting the autumnal sky', the building is nonetheless but a fragment of Holden's original scheme. Critall Windows are also found in almost all London-area Underground stations designed by Holden, and in numerous 'nautical Deco' residences and commercial buildings.

Deco Electrification

Probably the most significant technological advance of all was the development of widespread and plentiful electricity. Playing a key role in urban development, it eventually found its way into rural life.

design. A popular design for the wood cabinets that housed electrically powered radio-record players featured a stepped, 'waterfall' silhouette. Wood inlay, richly hued Bakelite knobs and a decorative grille over the speakers often enlivened the overall form.

Electricity also significantly contributed to the aesthetic dynamics of Style Moderne architectural façades and interiors – perhaps nowhere as magically as in cinemas. Whether presented as Egyptian temples or streamlined palaces of the future, they featured electrical neon signs and floodlights, and the soft, diffuse illumination of interior sconces and soffit lighting. However, the icing on the magical cake was surely air-conditioning. The Rivoli Theater on Times Square in New York was the first to test the new technology when it opened on Memorial Day

1925. Inaugural audiences flocked in, as much for the cool air as the featured film. Summertime went from being a movie-industry write-off to its most profitable season of the year.

However, innovative use of electricity was as crucial to the production and the projection of movies as it was to providing an enchanting ambience. The images that flickered across the screen were made even more magical when Al Jolson starred in *The Jazz Singer*, the first 'talkie', in 1927. Even without the Wall Street Crash and ensuing Great Depression, cinema would most likely still have become the visual entertainment medium of the age.

Style Moderne and Cinema

During the 1920s, and even more so in the Depression-devastated 1930s, cinemas provided popular art and entertainment to audiences in cities and villages around the world. At their peak in the mid-1930s, Hollywood movies were seen by more than 80 million people per week from London to Lucknow, Los Angeles to Amsterdam. As products themselves, films also promoted goods that included Style Moderne and modern lifestyles, and did more than any other form of promotion to make Art Deco an international style. Seen in black-and-white – the perfect, shimmering monochrome – Deco movie sets, costumes and iconic actors afforded both a respite from the grind and inspiration for enlivening daily life.

Hollywood studios produced about 800 films a year during the 1920s and 1930s. Of them, Paramount, RKO Pictures and Warner Brothers provided some of the period's most archetypal escapist movies, and many of its greatest performers. Paramount – which owned the above-mentioned, air-conditioned Rivoli Theater – was the first studio to call its top actors 'movie stars' and their numbers included Marlene Dietrich (1901–92), Gary Cooper (1901–61), Claudette Colbert (1903–96), Mae West (1893–1980) and Cary Grant (1904–86). Paramount was also the company that made the most of immigrant involvement in film production. This not only brought an international understanding of Style Moderne to filmic styling, but it also gave Paramount an edge in marketing its products outside the US.

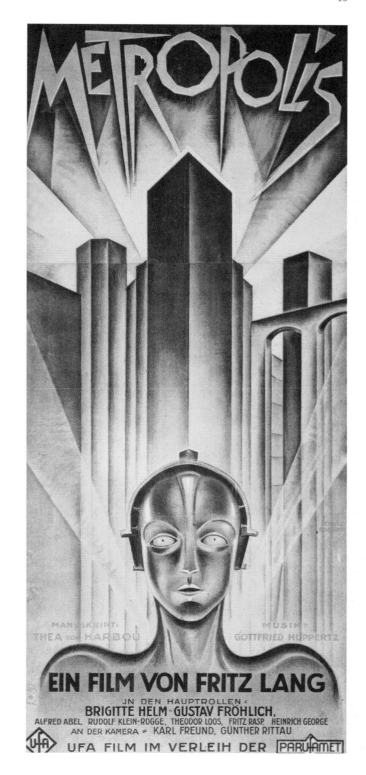

The 'Hot Voodoo' sequence from Paramount's *Blonde Venus* (1932), with Dietrich and Grant, begins with a gorilla backed by dancers who shimmy and bob to blaring horns and thumping drums. While Grant's character looks on intently, the gorilla slowly starts to strip, and Dietrich's character emerges. She dons a blonde wig, whose Afro styling echoes the natural coiffures of the dancers behind her, and sings, 'Hot voodoo, dance of sin. Hot voodoo, worse than gin.' As her act concludes, the black bandleader strikes up a jazz tune.

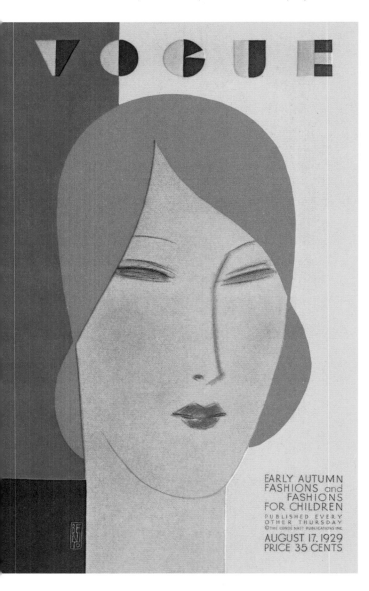

The relationship between popular entertainment, exotic sexuality and jazz – all of which were entangled with Art Deco tropes – is unmistakable.

RKO claimed *King Kong*, as well as the frothy world of Fred Astaire (1899–1987) and Ginger Rogers (1911–95). The Rogers–Astaire pairing was less exotic and less sexual than Dietrich and Grant, although not without frisson, and tended more towards elegance sprinkled with comic relief. Their most notable features for RKO were *The Gay Divorcee* (1934), *Top Hat* (1935) and *Swing Time* (1936). In their dancing, Astaire's black-and-white Deco angles are complemented by Rogers' taut, gleaming Moderne curves. Their movements transition from seamlessly smooth to momentarily abrupt, then back to a fluid motion that, while in some ways machine-like in their precision, remain very human.

A notably raunchier approach to dance came in films by Warner Brothers, the studio that made its name with tough-guy gangster films. At the same time that they were filming *The Public Enemy* (1931) and *'G' Men* (1935), the Warners were churning out movies about aspiring Broadway dancers and other young men and women looking for a leg-up. However, the potboiler plots of *Gold Diggers* films (1933, 1936 and 1938) and stories set in Hollywood and on Broadway are only scaffolds for musical numbers that are Art Deco artworks in themselves. Busby Berkeley (1895–1976) choreographed and staged them, and directed the camera work. As such, the 'By a Waterfall' number in *Footlight Parade* (1933) shifts from a tiered ziggurat of costumed dancers, a conventional stage view, to a purely cinematic, overhead perspective of concentric rings of dancing figures. In *42nd Street* (1933), the camera zooms into a triangular tunnel of dancers' parted legs, again a shot that relied on filmic innovation.

Style Moderne in Asia

Just as movies made Art Deco an international phenomenon, so did movie houses offer global audiences a direct experience of Style Moderne architecture. Cinemas were not, however, the only means by which Art Deco style was adopted around the world. Wealthy nations, societies and individuals responded to its potential almost immediately.

Linked in to new networks of communication, they were ready to embrace the modern style and express it using the costly materials promoted by French designers.

Interest in Art Deco among India's elite pre-dated 1925 and extended into the 1940s. A canopy bed, possibly a wedding gift for the Maharajah of Surgujah in 1922, is a case in point. Its wood frame is completely veneered in sheets of silver with repoussé zigzags, sunrays and other quintessentially Deco motifs and patterns. In a 1929 portrait by Bernard Boutet de Monvel, the Oxford-educated Maharaja of Indore is depicted as a suave cosmopolite in impeccable Occidental evening wear. Indore, or Yeshwent Rao Holkar, reached his majority in 1930 and celebrated the milestone by commissioning a new palace. Called Manik Bagh, the palace's furnishings included metal, glass and lacquered screens, Jean Puiforcat-designed silver, a Macassar ebony study by Ruhlmann and chairs from Eileen Gray and Le Corbusier.

A more public expression of Style Moderne transformed the city of Mumbai (Bombay), the portal to India for Western professionals and businesspeople. For example, the Soona Mahal apartment building at the corner of Marine Drive and Churchgate was completed *c.* 1939 (*see* right, top). Unlike most Art Deco contemporaries, it was not given a British appellation but was named after one of the builder's Parsi relations. Despite the conservatism of Indian culture, acceptance of Deco as an elite style led to development of an Art Deco enclave in the Back Bay district. Apartment homes for the Westernized upper classes, built along the corniche between 1929 and 1940, led to Mumbai being second only to Miami Beach as an Art Deco cityscape. From there, the style became pervasive throughout the city – largely due to the ubiquitous presence of cinemas. Mumbai had almost 300 movie houses by 1939, and theatres from Kolkatta (Calcutta) to Patna were decorated with schemes that mixed Hindu temple architecture, motifs derived from native vegetation, zigzag silhouettes and curving corners, and other characteristics of global Style Moderne.

Two more important Style Moderne cityscapes in Asia are the Bund and the Hongkou districts in Shanghai (*see* the the Cathay cinema on page 21, bottom), a city which, during the 1920s, was called the 'Paris of the East'. The style was brought in by American, English and

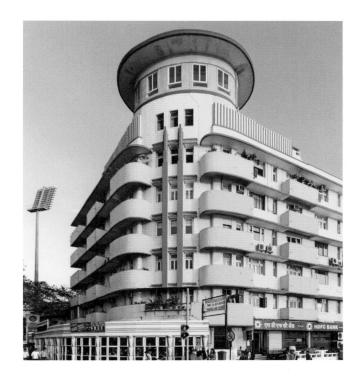

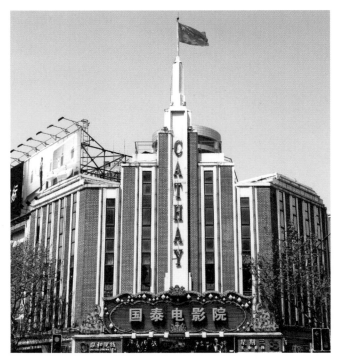

French capitalists, but naturalized due to its ability to be interpreted in local terms. The translation was further helped along by Chinese students returning to the city from Western universities to ply their trade at home. The Bund was populated by several Beaux-Arts-style structures, as well as various expressions of Victorian revival, but Art Deco was the favoured style at a time when money was there to be spent on architecture. The Bank of China building is a splendid example of 'Chinese Deco', although it is not the skyscraper it was originally conceived to be. Its more modest height is due to its location next to Sassoon House, which banking magnate Victor Sassoon insisted be taller than any other buildings nearby. Another prime example is found in Hongkou, where one of China's oldest museums, the British Royal Asiatic Society, was recently transformed into an exhibition space for contemporary art. To an extent, the building's exterior recalls the looming mass of London's Bankside Power Station, now home to the Tate Modern.

Art Deco in Canada and Latin America

Art Deco's most emphatic marks in Canada could be seen in architecture and in the graphic works that advertised tourism in the form of ship and rail travel to grand resorts and hotels. Canadian architects localized Deco buildings by incorporating motifs based on indigenous flora and fauna, including pine trees, moose, lobsters, turtles, seaweed, bears and – flanking the entrance of Toronto's Hydro-Electric Power Commission of Ontario building – waterfalls. Another important national theme, that of transport, is highlighted on the former railway station in Hamilton, Ontario, which is adorned with low-relief carvings of locomotives, steamships, trolleys and trucks. The Bank of Nova Scotia headquarters in Halifax is decorated with depictions of 86 plant and animal species. The lobby of the Marine Building, sometimes described as Vancouver's answer to the Chrysler Building, is an expression of genuine Art Deco exuberance, with decorations in marble intarsia, stained glass, ceramic tile and, for the lift doors, panels of inlaid hardwoods (see above).

Travel posters for Canadian Pacific, and its rival Canadian National Railways, represented glorious views of mountains, forests and water, with streamlined trains snaking through the landscape.

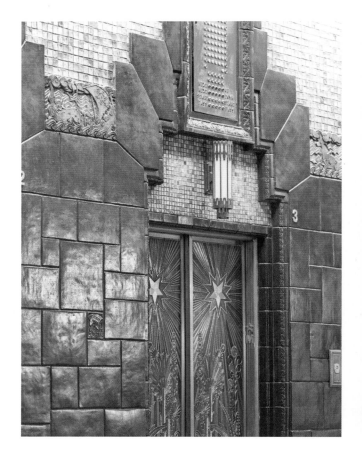

Created by Charles James Greenwood (1893–1965) and other designers, these images reflect modernity via graphic use of simple outlines, airbrushed shading and clear colours. A fuller and more characteristic use of Deco tropes is seen in posters depicting cruise ships, trains and urban landmarks.

In addition to architecture and graphics, Canada started producing Style Moderne furnishings and other domestic goods in the years following the 1925 Exposition. By the late 1920s, Canadian-produced pottery, furniture and other consumer goods were in stores. Chrome-plated metal – with all of its machine-age connotations – was a popular structural material for furniture, alone and combined with wood. Designers seem to have especially enjoyed creating lamps. Electrolier of Montreal and Toronto-based Coulter produced a series of lamps that featured multi-tiered metal shades that, again, sent a sleek, modern message.

For many Latin American cities, Art Deco was a means of proclaiming modernity and expressing unique heritage. Architecture was the ideal means of doing so, because it was visible to people of all social classes. For European colonizers, Deco could maintain links to, for example, the Beaux-Arts tradition by incorporating symmetrical composition and ornamented façades. At the same time, that ornamentation could incorporate references to pre-colonial, location-specific motifs – as was the case in other cultures taken over by European colonizers. Ironically, although Aztec motifs contributed to Style Moderne designs in European cities, there is relatively little such indigenous decoration in Mexico City. Instead, the city's 1920s- and 1930s-era buildings generally incorporate geometric abstraction and the linear tropes found in global Style Moderne.

A different kind of colonial dominance is seen in Rio de Janeiro, where the towering sculpture known as *Christ the Redeemer* is set on top of the area's tallest massif, Corcovado. As much an engineering feat and a product of collaboration as it is an iconic sculpture, it is made from thousands of carved soapstone pieces attached to a reinforced concrete structure. As an expression of Roman Catholic Christianity, it speaks of the religious conversion of indigenous peoples.

Art Deco in Africa

The deployment of Style Moderne architecture was perhaps one of the last expressions of colonial culture in Africa, an expression of European modernity in places where Europeans were a minority. In Eritrea, Deco was a representation of Italian hegemony. Asmara, the nation's capital, was a favourite site for Italian architects, who wished to test new design concepts, often using local materials. The Cinema Impero (*see above*) was built in 1937 by Eritrea's Italian colonizers. At the time of its construction, it was the city's largest cinema. Its name alludes to Mussolini's conquest of Ethiopia and his proclamation of an Italian empire. Along with the quintessential Art Deco building forms that were cinemas, the city is home to a Fiat service station in the form of a Moderne aeroplane, a Deco bowling alley and a building whose main façade resembles the cabinet for a radio set.

Another, perhaps initially surprising, centre of the Streamlined iteration of Style Moderne is Bukavu, in the Democratic Republic

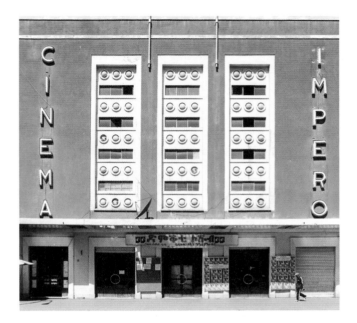

of Congo. During the Belgian colonial period, the city became a showplace for an architecture of crisp edges, horizontal profiles and rounded corners. Decades of violent turmoil have left many of Bukavu's buildings in a tattered condition, but in their original form.

Art Deco buildings are situated in several South African towns and cities, among them Johannesburg, Springs, Cape Town and Durban. The 1936 Empire Exhibition in Johannesburg marked a highpoint of development in that style and today the city is often cited as having the world's third-largest cache of Deco buildings in the world. Most of the construction took place during a boom time that, paradoxically, coincided with the Great Depression felt by most of the world. Due to steep increases in the value of gold, commercial interests in Johannesburg were able to build grand, Manhattan-inspired expressions of their wealth and power. Chrysler House, which occupied an entire city block, featured lifts that carried cars to parking levels up to the ninth floor. It was completed in 1937, in a variation of Streamline Moderne that incorporated both vertical and horizontal strips of windows into its ziggurat-stepped mass.

As could be expected, Casablanca's Style Moderne architecture is more closely linked to Parisian Deco's luxury than other cities on the

African continent (see the interior of the Hotel Guynemer above). Not accidentally either. After taking control of Casablanca in the early twentieth century, France was determined to transform it into a demonstration of its glorious civilization and its chic. Of special interest is the impeccably crafted wrought-iron grille work – some of it purely abstract and geometric, some incorporating stylized peafowl, fountains and flower blossoms.

Australia and New Zealand

From skyscrapers to cinemas, Australia has more than its share of iconic Art Deco buildings – designed with sophistication and executed with notable skill. A case in point is Sydney's former City Mutual Life Assurance building. Its impressive entrance is overlooked by a high-relief bronze casting called *Flight from Vesuvius*. It was sculpted by Rayner Hoff (1894–1937), who also created low-relief friezes and fully three-dimensional figural works for the city's ANZAC War Memorial. The potential for Art

Deco to be naturalized, to connect with local interests and motifs, is seen in Canberra's Australia War Memorial and in the former Australian Institute of Anatomy, now the National Film and Sound Archive. Both feature relief carvings of indigenous flora and fauna, but the War Memorial's inclusion of the heads of an aboriginal man and woman have long been controversial. Many critics consider them to be ugly and that they align these humans on a level with beasts. The Film and Sound Archive's design more effectively incorporates goanna lizards into the capitals of the columns and pilasters of the main façade, which is also decorated with geometric glazed-tile panels. The central compartment of the building's stained-glass foyer skylight contains a marvellous stylized platypus.

However, for sheer preponderance of Style Moderne architecture, Napier in New Zealand (*see* below) is unmatchable. Almost completely levelled by an earthquake in 1931, the city chose optimistic Art Deco styling for a wide range of buildings, including domestic, institutional and commercial structures. The construction budget was tight, but architects were able to evoke the aura of Deco by using relatively inexpensive materials and keeping detail to a minimum. Low-relief panels that cap pilasters and trim the coffered ceilings of the ASB Bank are decorated with Maori-inspired stylizations of natural forms. The exteriors of buildings in the centre of town display sunbursts, chevrons, tiered curves, palmettes, curved corners and many other characteristics of Deco. The city's style heritage is protected by the Art Deco Trust.

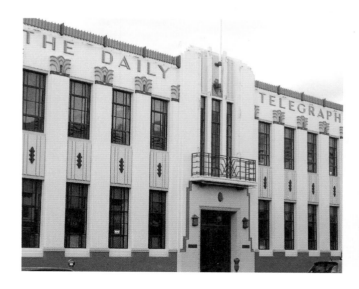

Style Moderne in Europe

By 1925, Style Moderne had reached its peak of maturity, not only in France but elsewhere on the Continent. Different regions developed their own permutations of modern style, ranging from Fascist monumentality in Italy to fluid classicism and a continued emphasis of skilled craft in Scandinavia to brilliant Eastern European mixtures of folk motifs and colours with crisp, geometrically inspired silhouettes.

Although progressive Italian artists of the early twentieth century emphasized speed and dynamism in their modern two- and three-dimensional designs, Benito Mussolini (1883–1945) construed modernity in terms of brute power and force that he believed revived Roman grandeur. Architectural and sculptural forms became massive, rather muscle-bound – effectively a classical form of Art Deco. The façades of many railway stations and, one of Mussolini's favourite structures, stadiums, were characterized by monumental expanses of limestone, travertine and different kinds of tuff that were set off by relief carving.

The first example of Style Moderne architecture in Paris, the Théâtre Champs Élysées (see right) was completed in 1913, and was the venue for the Ballets Russes. Its bas-relief frieze is by Antoine Bourdelle.

Each of the Nordic nations had its own history and cultural identity to express via design. Denmark and Sweden had traditions of royal patronage which supported a love of Mediterranean classicism and a degree of luxury production. Norway and Finland, recently independent, sought to assert national identity informed by folk art and craft. The classical style, termed 'Swedish Grace', is probably best exemplified by the work of sculptor Carl Milles (1875–1955), most fully articulated in the buildings and grounds of his home and studio near Stockholm. Art Deco's adaptability and its eclecticism is reflected in Milles's collection of architectural columns, ceramic wares and folk furniture. Mediterranean classicism, however, was Milles's prevailing inspiration in terms of both subject matter and fluid style. The contours and details of these artefacts inspired his bronze and stone figures of Orpheus, numerous nymphs, and Europa and the Bull – as well as functional pieces such as vases and lamps.

Although much of Poland's Art Deco infrastructure was destroyed by the Nazi invasion of 1939, crucial artefacts were preserved in the United States, due to Polish participation in the 1939 New York World's Fair. Graphic arts, sculpture and painting reflected the important influence of folk art, and the nation's desire to honour its traditions and look to the future. One painting, *The Polish Madonna* by Irena Lorentowicz (1908–85), shows the Virgin wearing a peasant headdress and, with her baby, surrounded by vibrant floral and foliate patterning. Zofia Stryjenska (1891–1976) honoured traditional culture in drawings that fuse Art Deco with graphic expressionism. Best known, however, is Tamara de Lempicka (1898–1980), who made her name in Paris and New York by painting sensuously styled portraits of aristocrats (*see* page 34) and fashion plates. Aristocratic by birth, her big break came when she displayed two paintings in the 1925 Expo. One of her best-known images is a self-portrait, painted in 1929. Stylistically, it reflects the cubistic machine aesthetic of Léger, combined with a personal statement of independence. Cool and inaccessible, she sits behind the wheel of a Bugatti race car – a flight of fancy, given that her own car was a little Renault. The picture was featured as cover art for the German fashion magazine *Die Dame*.

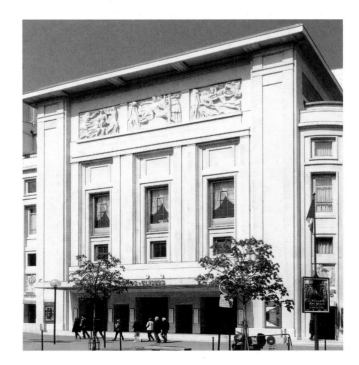

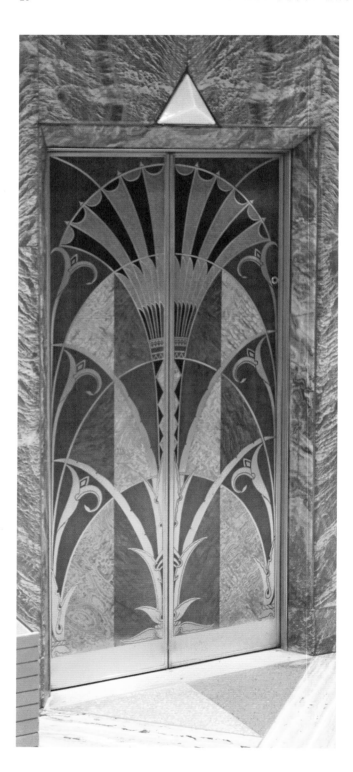

The United States

The fullest spectrum of Art Deco design – in terms of styling, materials, products, buildings, graphics and machines – was in the United States. Seemingly every city and town, from Meridian, Mississippi to Boise, Idaho, had at least one Style Moderne building that expressed American wealth and optimism or, at least, the desire to appear modern.

New York had the Empire State Building, the Rockefeller Center and, of course, the Chrysler Building (*see* left), whose interior and exterior displayed imaginative welters of Art Deco extravagance. Visitors to William Van Alen's structure, which debuted in New York in 1930, were dazzled even by its lift doors. Each pair features a foliate motif in bronze alloy, surrounded by wood veneers that include Japanese Ash and American Walnut, along with other hardwoods. However, it was that landmark's upward thrusting form that influenced countless other cities to similarly express their modernity. The irresistible verticality of American skyscrapers was permitted only because they conformed to zoning laws that called for such buildings' mass to be mitigated by setbacks (step-like recessions). The resulting ziggurat-like forms were in perfect harmony with Deco geometry.

Tall buildings, adorned with geometric patterns and quotations of ancient cultural motifs were found in cities throughout the United States. Perhaps surprisingly, one centre of ambitious Deco design was Detroit, whose wealth during the 1920s seemed as vast as that of New York. Detroit still boasts a number of important Style Moderne skyscrapers, but one of its jewels is the Guardian Building. Completed in 1929 on the eve of the banking crisis, it is a symphony of brightly coloured geometric shapes inspired by Mesoamerican patterns, executed in glass and ceramic tile, sound-absorbing textiles and massive pieces of carved, rare marble.

On the west coast, both interior and exterior of the Mayan Theater in Los Angeles bristle with zigzag bas-relief panels, mask-like, glazed terracotta faces, and medallions that recall the circle-shaped Mayan calendar. The sprawling 1929 factory for the Samson Tire and Rubber Company in Los Angeles was patterned after the palace

of Assyrian King Sargon II. At the time of its completion, it was the largest manufacturing structure west of the Mississippi River.

The Fall and Rise of Art Deco

A mix of factors led to the end of Art Deco – foremost, perhaps, the beginnings of the Second World War. The conflict took millions of lives, destroyed cities and countryside, and drained national budgets. It also led to an exodus from Europe to the United States of important graphic, industrial and architectural designers who lived by Mies van der Rohe's maxim: less is more. After the war was over, the US was wealthier and more powerful than ever, and its money was spent on such designers as van der Rohe, Eero Saarinen (1910–61), Herbert Bayer (1900–85), Walter Gropius (1883–1969) and Marcel Breuer (1902–81) – Modernists whose designs, in Gropius's words, emanated 'inner laws, free of untruths or ornamentation'.

Because it incorporated decoration, and because it did not follow inner laws, Art Deco was scorned by the dogmatists of modern design. Modernity became the International Style – not because it was adaptable to local cultural ways, but because its buildings were required to display the same stark, rectilinear characteristics, no matter where they were.

Yet dogmatism invariably leads to rebellion, and Modernism eventually fell to a rebellious art and design rabble. In visual art and graphics, Pop artists such as Richard Hamilton (1922–2011), Roy Lichtenstein (1923–97) and Andy Warhol (1928–87) brought references to commercialism and mass production to their works. Joyce Kozloff (1942–) and other Pattern and Decoration artists celebrated intense, jostling colours and folkloric motifs. Cheeky graphic designers for Pushpin Studios in New York and Pentagram in London challenged the International Typographic Style launched in Switzerland, which served as a two-dimensional counterpart to International Style architecture.

In furniture and architecture, the Memphis Group and its founder Ettore Sottsass (1917–2007) found inspiration in Style Moderne and Pop Art for their irreverently colourful and disjointed designs. Their use of such materials as plastic laminate stood in diametric opposition to such

Modernist icons as Mies van der Rohe's steel and leather Barcelona Chair of 1929. Postmodern architects Robert Venturi (1925–) and Denise Scott Brown (1931–) travelled the US to study examples of vernacular architecture, including 'googie', a vulgar, futuristic approach to modernity that was most often used in design of drive-up restaurants, gas stations, casinos and other commercial buildings.

As they sought out visual styles that would succeed Modernism, designers and collectors during the 1960s and '70s rediscovered Style Moderne. Renaming it 'Art Deco' or, simply, 'Deco', made it fresh for new generations to enjoy on their own terms, while savouring its place in history. The embrace of Art Deco opened the door to expressiveness and fun. It allowed Modernism to be appreciated as one of many historic genres of design. Adaptable, consumable and enjoyable, Deco reborn gave design a bright, new future.

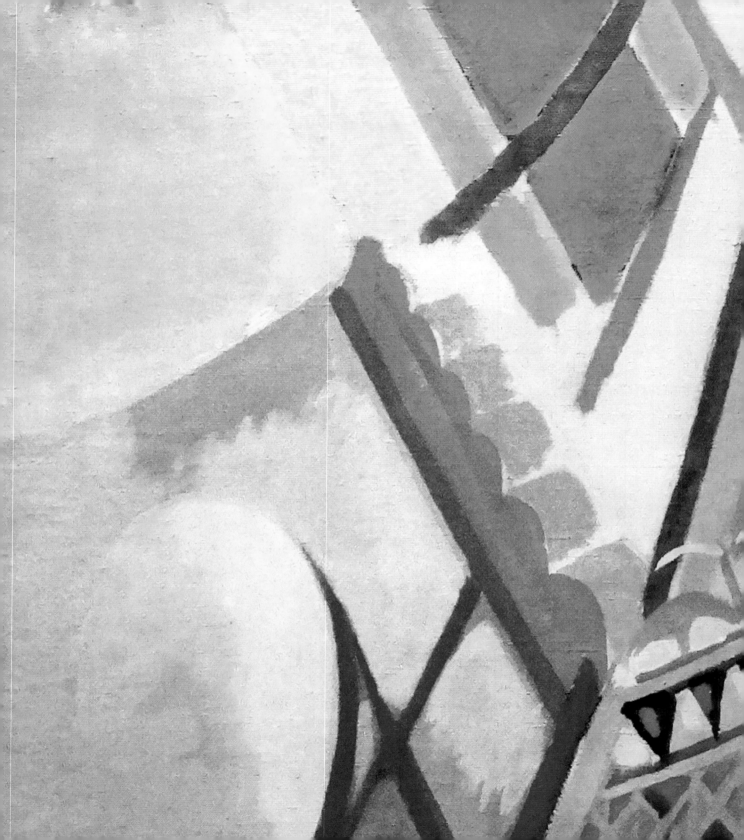

Fine Art

Fine art played a minor role in the Art Deco world, which emphasized design, but notable artists made exciting contributions that blurred boundaries between fine and applied art.

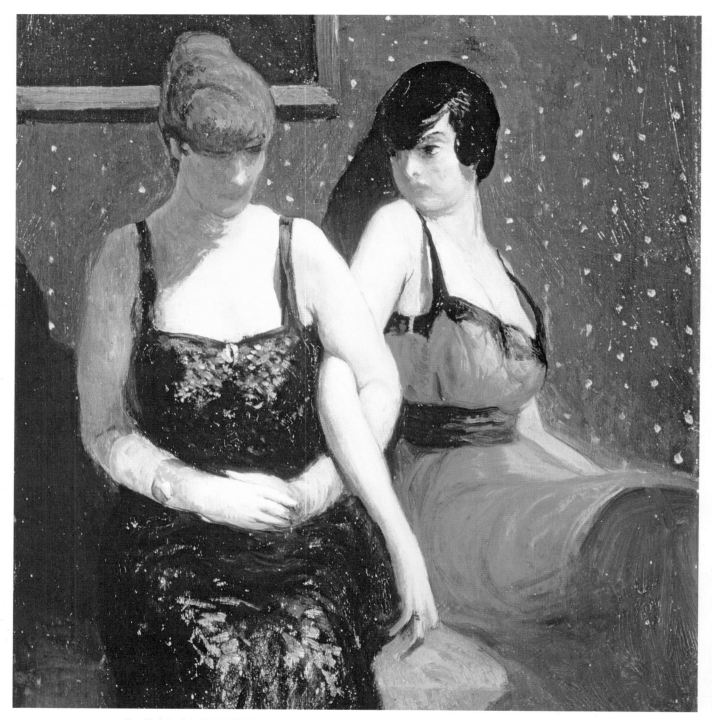

Guy Pène Du Bois (1884–1958)
Oil on canvas, 73 x 92.4 cm (28¾ x 36⅓ in)
• Private Collection

The Sisters, 1919 Brooklyn-born Guy Pène du Bois produced written and pictorial cultural commentary. Like many of his pictures of women in pairs, *The Sisters* simmers with tension. Dressed in evening finery, these two comprise a study in contrasting temperaments.

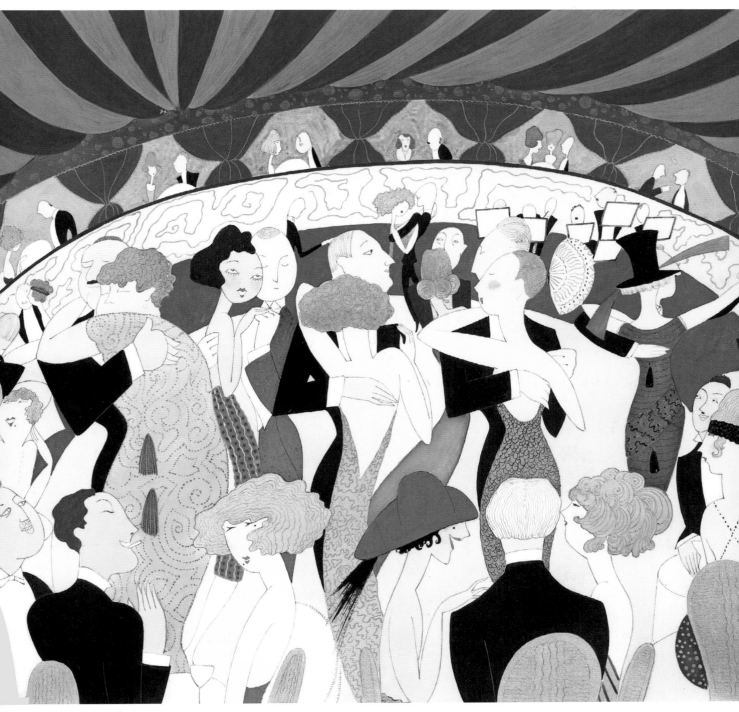

Anne Harriet Fish (1890–1964)
Ink, watercolour, gouache, silver paint and pencil on paper,
72.5 x 55.1 cm (28½ x 21⅝ in) • Library of Congress, Washington, D.C.

***Dancing Couples*, cover for *Vanity Fair*, 1921** Anne Harriet Fish's drawing of dancing couples displays
several Deco characteristics. They include overall symmetry and flat patterning, and crisply outlined
shapes of people, their clothing and the setting – thus reducing all elements to the function of decoration.

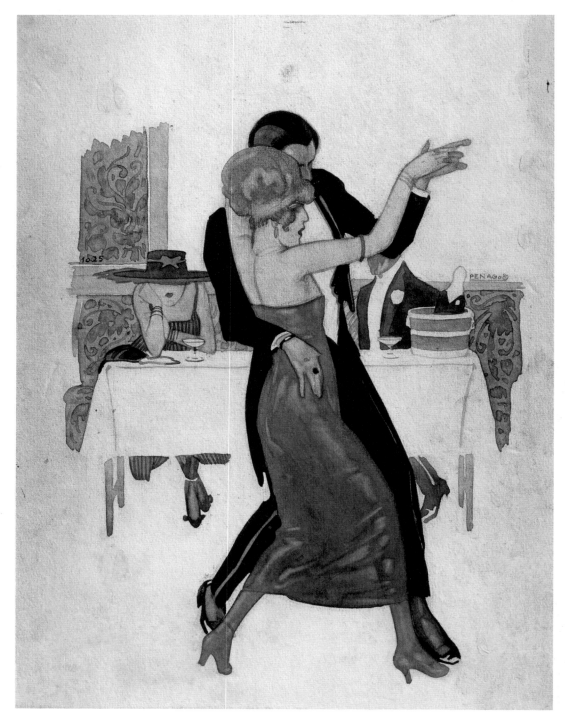

Rafael de Penagos (1889–1954)
Watercolour and gouache on paperboard • Private Collection

***The Tango*, 1921** The strong horizontal and vertical elements in this picture are relieved by the subtle but emphatic diagonals of the dancing couple's bodies, and by the manifest, vaguely amusing, boredom of the seated woman at the table behind them.

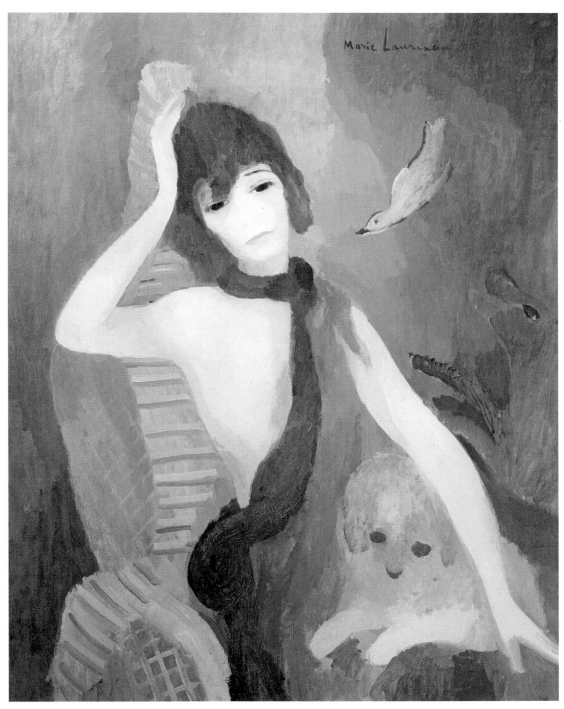

Marie Laurencin (1883–1956)
Oil on canvas, 92 x 73 cm (36¼ x 28⅓ in) • Musée de l'Orangerie, Paris

***Portrait of Mademoiselle Chanel*, 1923** When Marie Laurencin painted this portrait of Coco Chanel, both women were working on productions for Sergei Diaghilev's Ballets Russes. This context might help account for the atypically harsh colours Laurencin used to evoke Chanel's candid sensuality.

34

Tamara de Lempicka (1898–1980)
Oil on canvas, 81 x 130 cm (31⅔ x 51 in) • Private Collection

Portrait of the Marquis d' Afflito, **1925** Tamara de Lempicka portrays this dapper nobleman as a tuxedo-clad Venus of sorts. The figure makes mesmerizing eye contact with viewers, but the treatment of Afflitto's figure and his environment are cubistic and abstract, paradoxically enhancing the sexual tension.

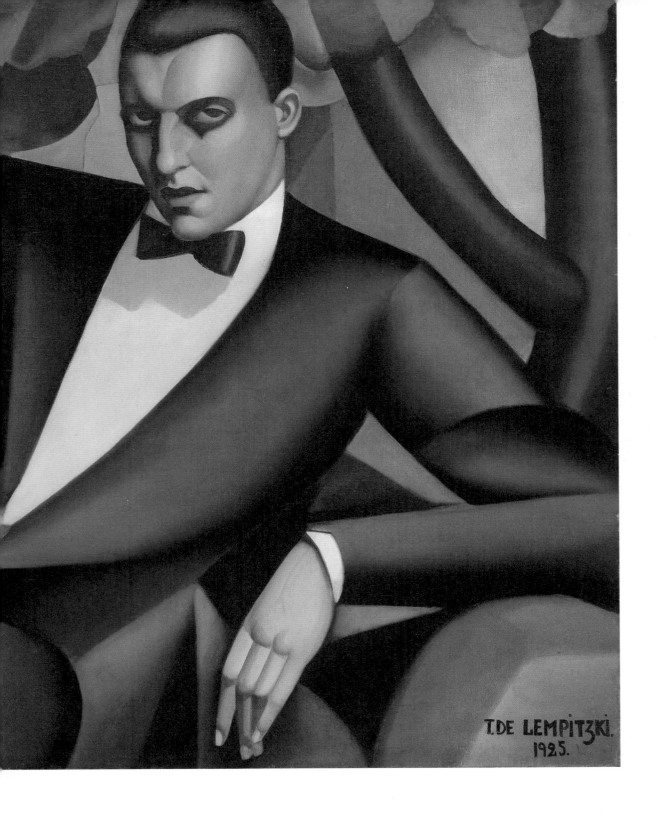

T. DE LEMPITZKI.
1925.

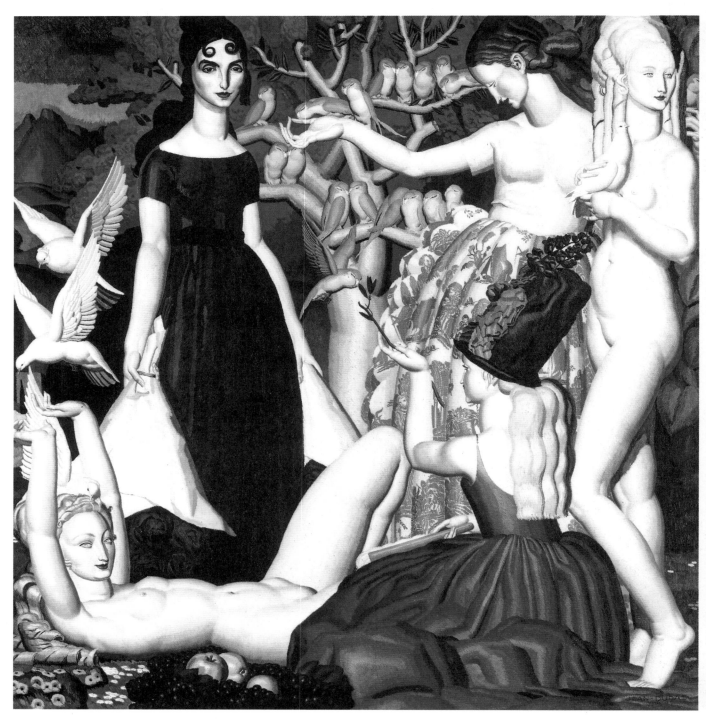

Jean Théodore Dupas (1882–1964)
Oil on canvas, 200.7 x 200.7 cm (79 x 79 in) • Private Collection

Les Perruches, 1925 Jean Dupas' graphic illustrations were seen by innumerable readers of *Vogue* and *Harper's Bazaar*, and by countless riders on the London Underground. However, *Les Perruches* is his best-known work, having been featured in Émile-Jacques Ruhlmann's Grand Salon at the 1925 Exposition.

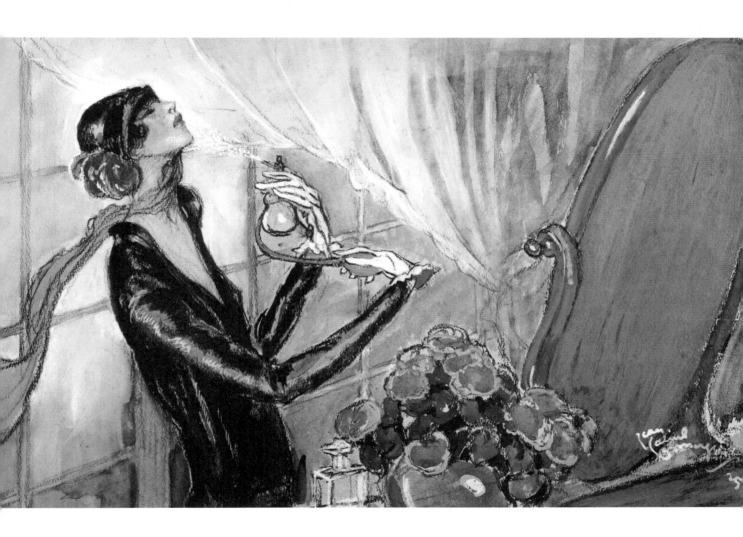

Jean Gabriel Domergue (1889–1962)
Pencil, watercolour and gouache on paper

The Flapper (La Garçonne), c. 1925 The artist's image of an androgynous woman applying fragrance – the iconic, rectilinear bottle on her dressing table suggests it is Chanel No. 5 – stands out in an oeuvre that overall evokes the Gay Nineties more than the Roaring Twenties.

René Vincent (1879–1936)
Watercolour on paper • Château Musée, Dieppe, France

Bather, *c.* 1925 Crisply interlocking curves, bright colours, flat patterns and the bather's athletic form
signal a new kind of femininity in René Vincent's deft watercolour. It could also echo two Chanel innovations:
the 'little black dress' and the suntan.

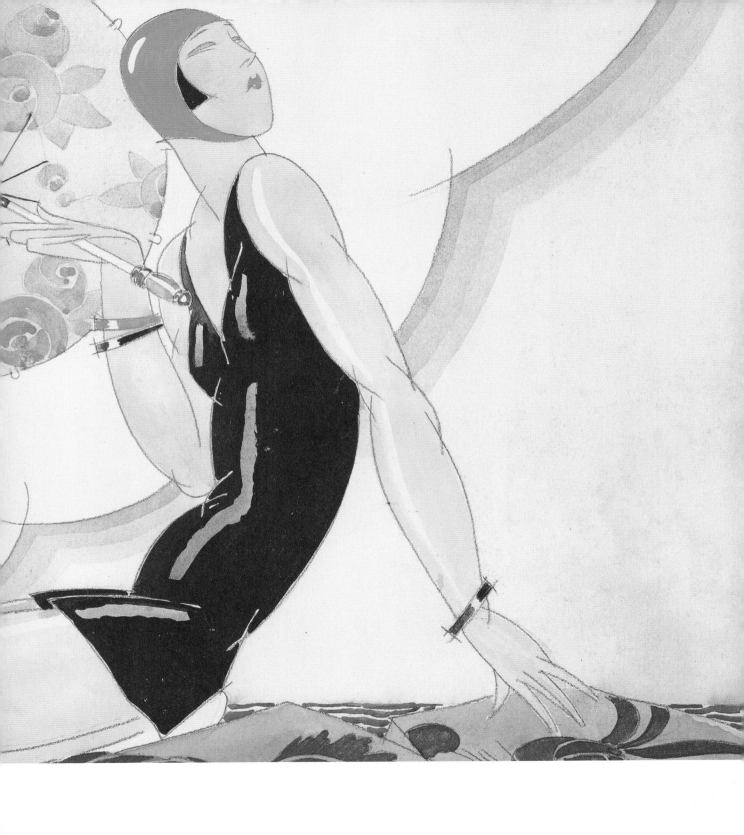

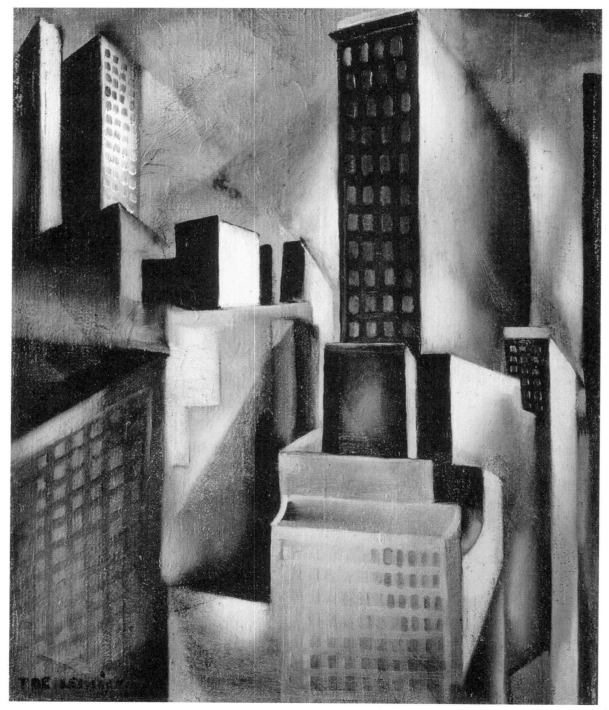

Tamara de Lempicka (1898–1980)
Oil on canvas, 46 x 37.8 cm (18 x 14⅞ in) • Private Collection

New York, **1925–35** Manhattan skyscrapers were an irresistible subject for artists, American and foreign. For Lempicka, a Pole, they symbolized a dynamic, urban future and presented a perfect subject for the cubistic forms she was pursuing at the time.

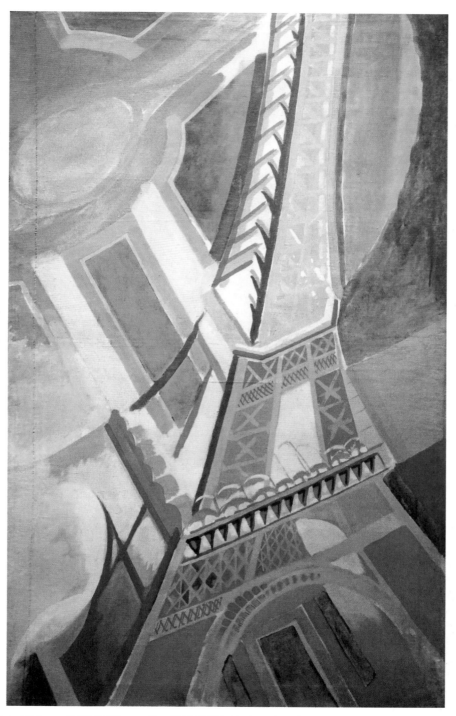

Robert Delaunay (1885-1941)
Oil on canvas, 169 × 86 cm (66½ x 33⅗ in)
• Musée d'Art Moderne de la Ville de Paris

***Tour Eiffel*, 1926** In his views of the Eiffel Tower, Robert Delaunay does
not depict an architectural structure as much as a network of lines. The flat
shapes thus created are filled with jarring colours.

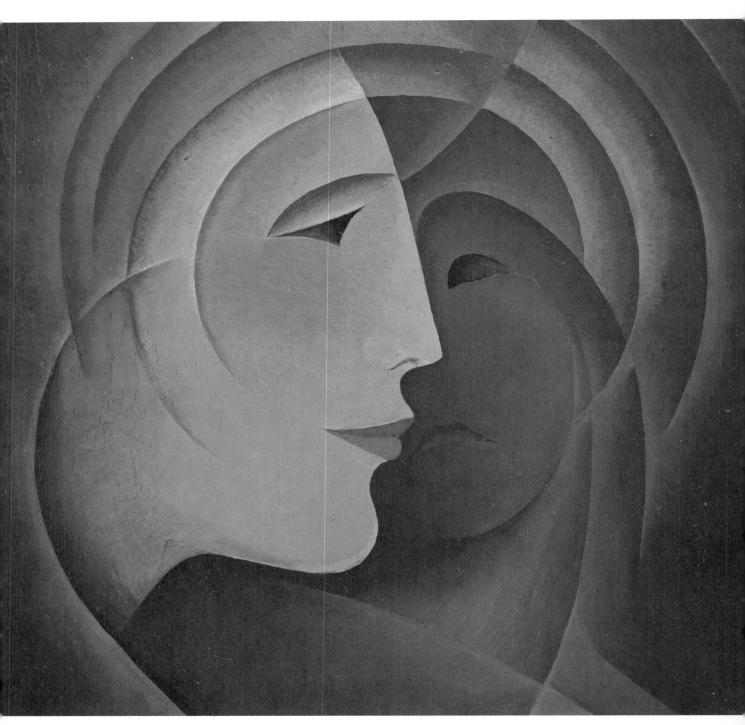

Thayaht (Ernesto Michahelles, 1893–1959)
Oil on cardboard • Private Collection

Compensazione di Temperamenti, **1926** Known by the palindromic pseudonym 'Thayaht', the Italian industrial designer Ernesto Michahelles advocated forward thinking. Here, he seems to suggest the practical benefits of pragmatically bringing one's attitude into harmony with the future.

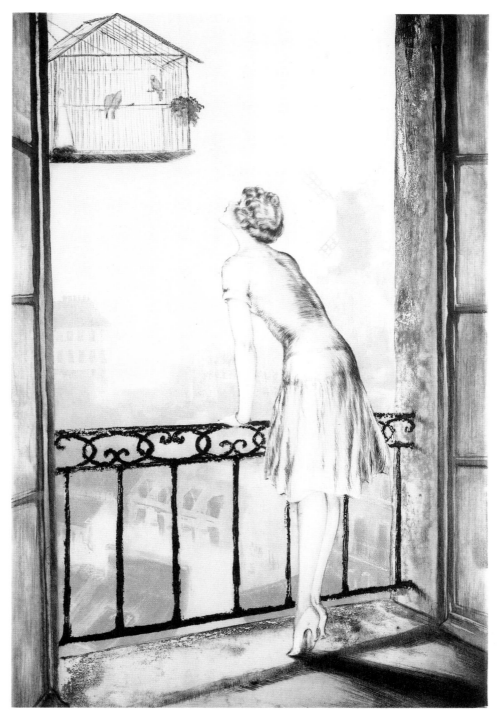

Louis Icart (1888–1950)
Colour etching and aquatint, 72.5 x 53 cm (28½ x 20⅓ in)
• Private Collection

Montmartre, **1928** Louis Icart's depictions of Bohemian life in Paris between the wars are a far cry from Art Deco in their styling, but they were immensely popular for their wistfully sunny – and occasionally erotic – romanticism.

Guy Pène Du Bois (1884-1958)
Oil on panel, 66 x 78.7 cm (26 x 31 in)
• Brooklyn Museum of Art, New York

***Woman on Sofa*, 1927** The sitter's frothy bob, drop-waist dress, skimpy pumps and very long strand of beads identify her as a flapper. And, for good measure, her pose is rather scandalously informal. More the sort of thing one would expect from an odalisque.

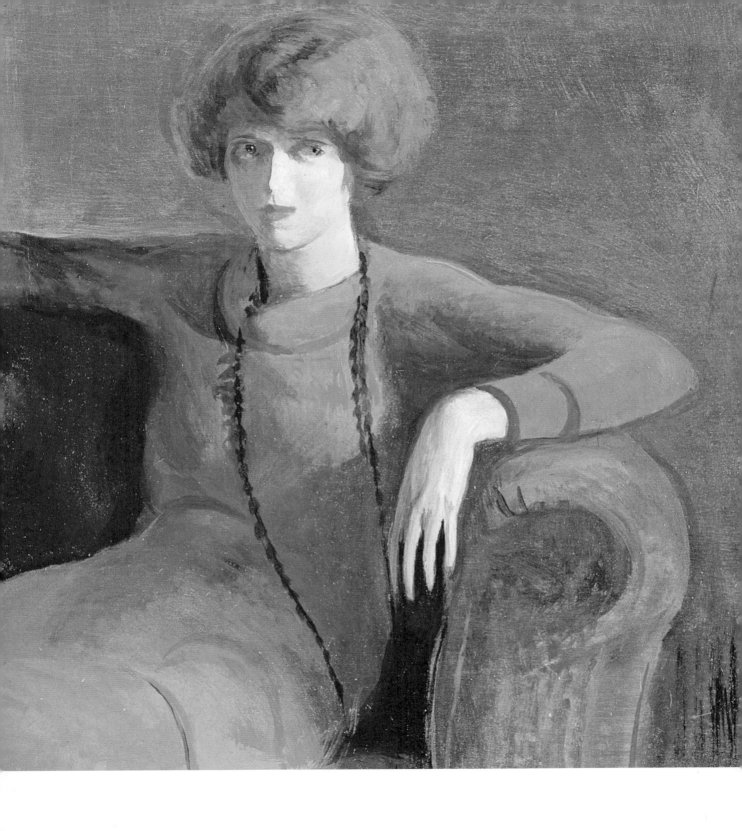

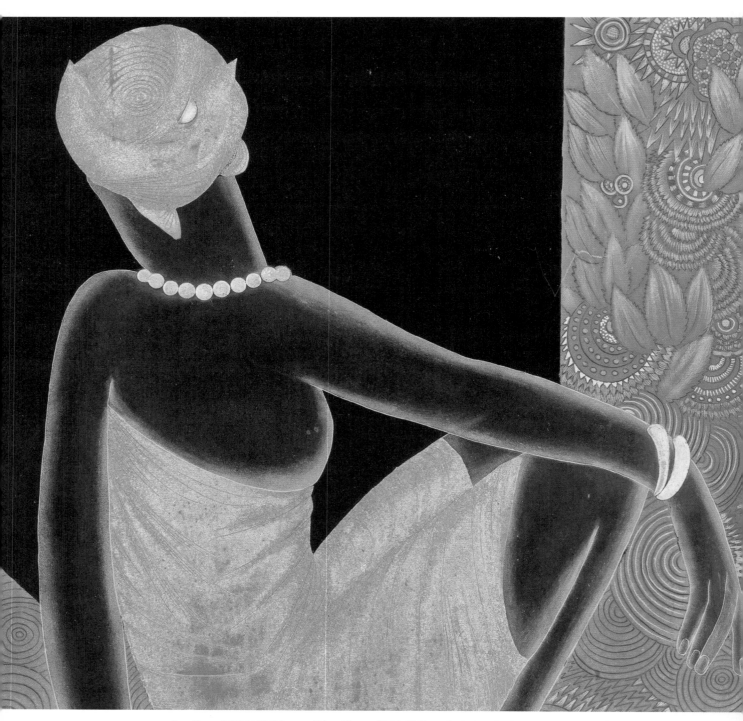

Jean Dunand (1877–1942)
Lacquered wood and oxidized copper, 92.7 x 64.1 cm (36⅔ x 25¼ in)
• Metropolitan Museum of Art, New York

African Woman, **1928–30** The stylized, simplified figure of a black woman becomes another abstract element in Jean Dunand's lacquered wood image. Painstaking to work with and exotic in effect, lacquer was an important medium in Style Moderne decoration.

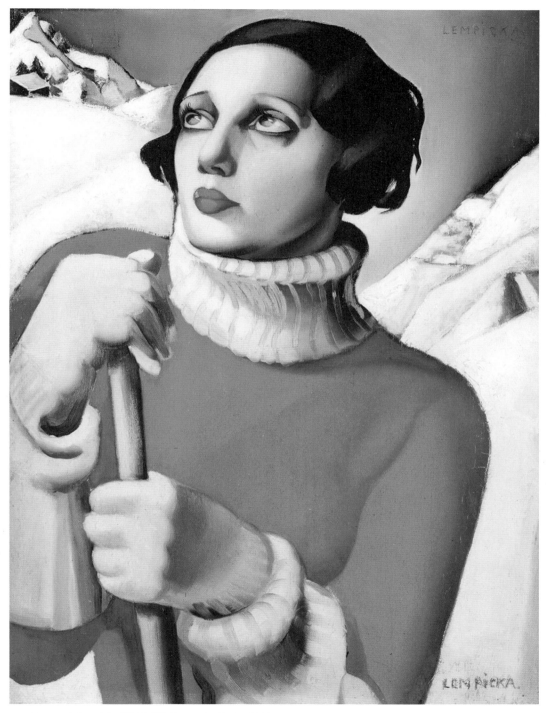

Tamara de Lempicka (1898–1980)
Oil on panel, 35 x 26 cm (13¾ x 10¼ in)
• Musée des Beaux-Arts, Orléans

St. Moritz, **1929** At this stage of her career, Tamara de Lempicka's style was less cubistic, more neoclassical. This image of a tanned woman against a snowy backdrop could be an advertisement for the historic Swiss resort, if not for her rather apprehensive expression.

Paul Colin (1892–1985)
Pochoir print, 46.3 x 63.9cm (18¼ x 25 in) • Private Collection

Jazz Band, **1929** The American musicians and dancers of 'La Revue Nègre' made their explosive debut in Paris in 1925. Four years later, the French artist Paul Colin would dedicate a portfolio of pochoir prints, called *Le Tumulte Noir*, to the troupe and its star, Josephine Baker.

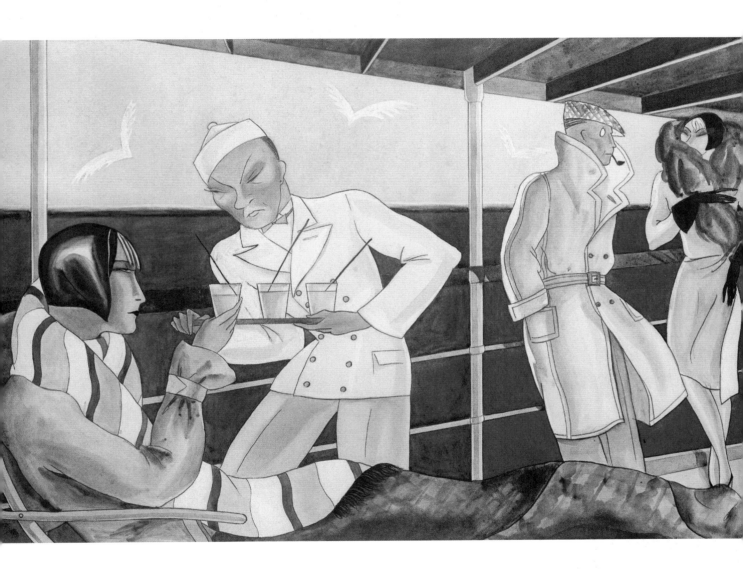

Dodo (born Dörte Clara Wolff, 1907–1998)
Gouache over pencil on cardboard, 47.5 × 65.8 cm (18¾ x 26 in)
• Private Collection

Faint Idea, 1929 Relaxing as sea voyages might be, this one is fraught with tension. The exaggerated postures of all four actors on this shallow stage, the backdrop of grey sky, wheeling gulls, hyper-fashionable women, and aggressively blue sea impart a sense of dangerous drama to even this simple scene.

Jean Théodore Dupas (1882–1964)
Watercolour on paper, 50.8 x 50.8 cm (20 x 20 in) • Private Collection

Harmonie de Rose, **1930** Jean Dupas continued to explore pairings of glamorous women with exotic flora and fauna. Here, however, his focus is on the figure's filmy evening gown and flowing stole. The model has an elongated, columnar form that is almost architectural.

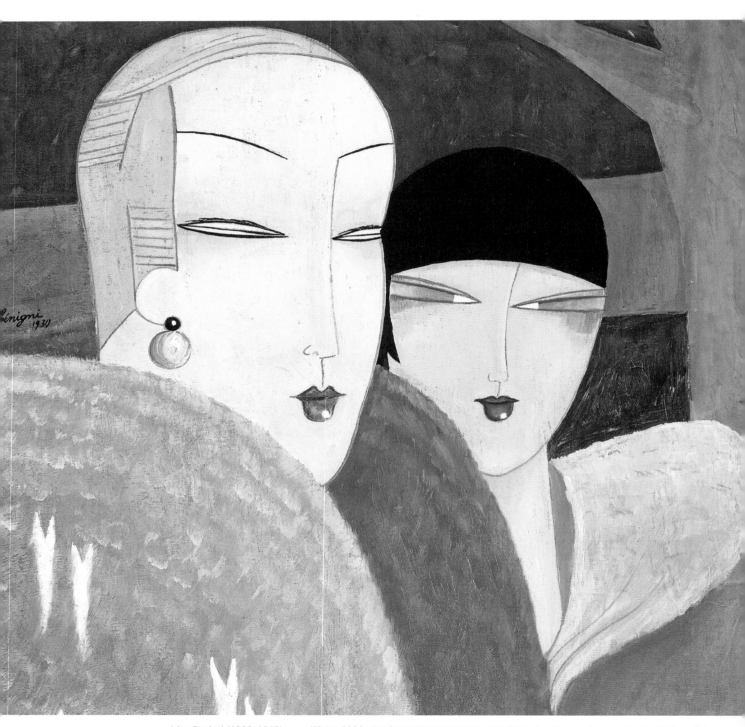

Léon Benigni (1892–1948)
Oil on canvas, 55.3 x 39.4 cm (21¾ x 15½ in) • Private Collection

***Winter*, 1930** Léon Benigni illustrated designs for the couture houses of Jeanne Lanvin, Madame Grès and Jean Patou, as well as for Cadillac automobiles. His clean, taut lines made it clear that elegance and modernity were not mutually exclusive.

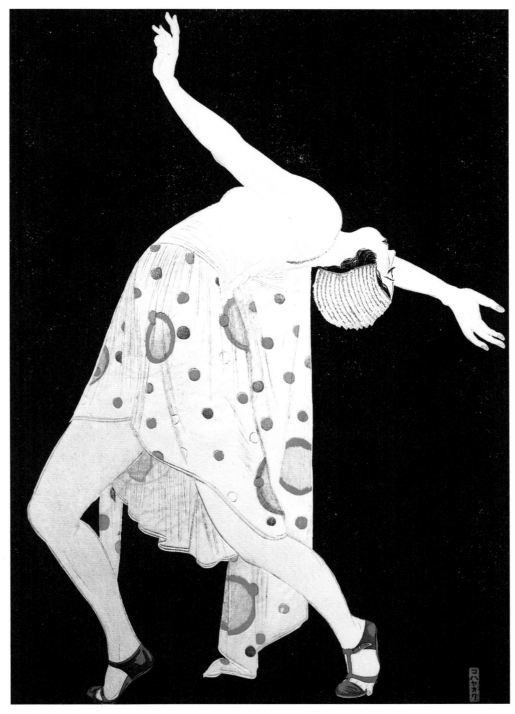

Kobayakawa Kiyoshi (1899–1948)
Woodblock print on paper, 60.96 x 50.8 cm (24 x 20 in)
• Levinson Collection

Dancer, or *Curved Line of the Instant*, **1932** When Art Deco achieved global popularity, the finely outlined, flat patches of colour that inspired the Western love of Japanese woodblock prints returned home. Kobayakawa Kiyoshi updates traditional style in his portrayal of a 'moga' ('modern girl').

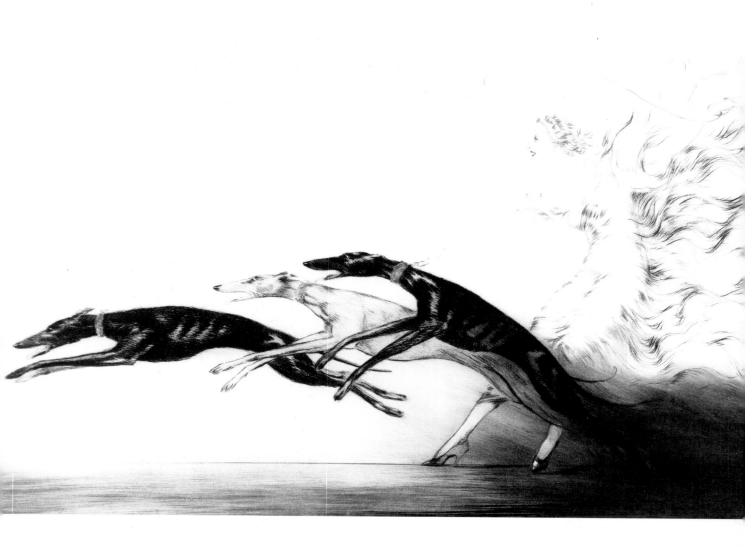

Louis Icart (1888–1950)
Colour etching and drypoint, 38 x 63 cm (15 x 24⅘ in)
• Private Collection

Speed II, 1933 Along with borzois, sleek greyhounds embodied Art Deco's dynamic grace. And Icart's sequencing of these three – arching forward and preparing to bound off the page – perfectly exemplifies the aesthetics of the age.

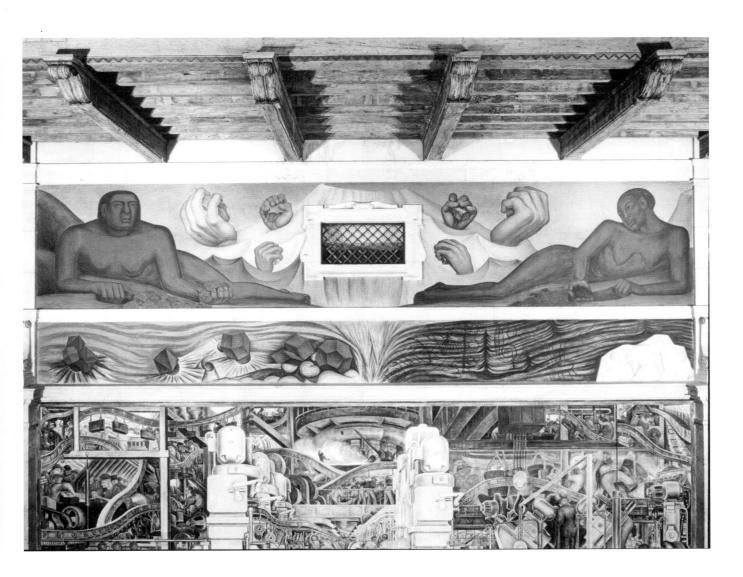

Diego Rivera (1886–1957)
Fresco, 1310 x 2040 cm (151⅜ x 803 in) • Detroit Institute of Arts

Detroit Industry, **north wall fresco (detail), 1933** Diego Rivera's masterpiece in true fresco takes viewers behind the scenes of daily life during the late 1920s and early 1930s. Although stylized, his depiction of workers on a Ford Motor Company assembly line is remarkably accurate.

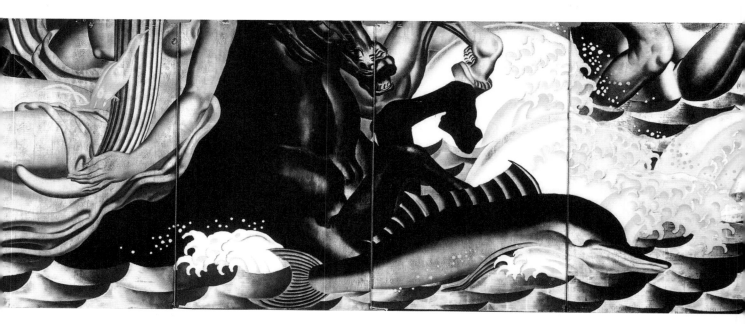

Jean Théodore Dupas (1882–1964)
Verre églomisé, 124.5 x 79.4 cm (49 x 31¼ in) • Private Collection

Four panels from a *Birth of Aphrodite* mural, 1934 In engineering and decoration, The SS *Normandie*, for which this mural was designed, was the floating epitome of Art Deco at its most fabulous. Although she was ultimately scrapped, many of her treasures survived – including Dupas' extraordinary gilded glass panels.

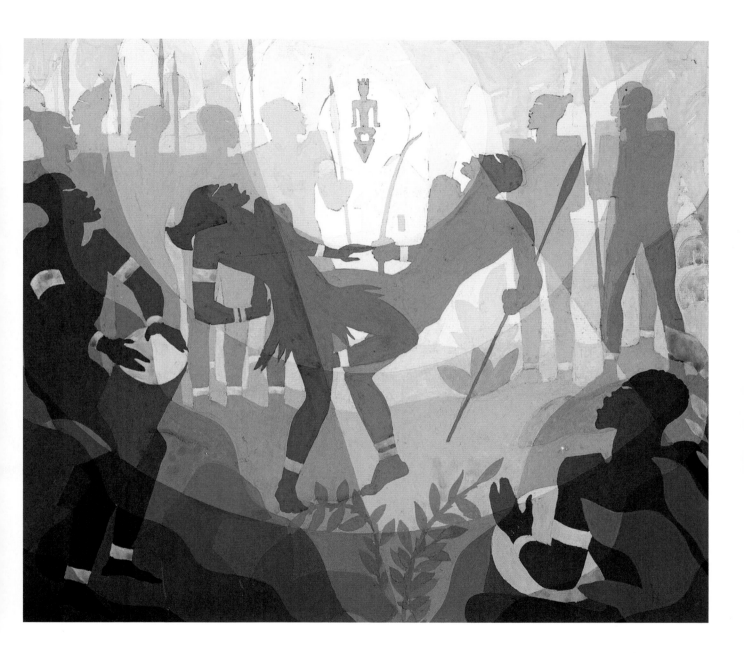

Aaron Douglas (1899–1979)
Gouache and graphite on illustration board, 37.2 x 40.6 cm (14⅔ x 16 in)
• The Art Institute of Chicago

***The Negro in an African Setting* (study), 1934** Aaron Douglas was the foremost visual artist of the Harlem Renaissance, a cultural awakening of African-Americans living in the north of the USA, which partially stemmed from but also contributed to social changes, including urbanization, that influenced Art Deco. This study was part of a mural titled *Aspects of Negro Life* that celebrates African influences on modern Western culture.

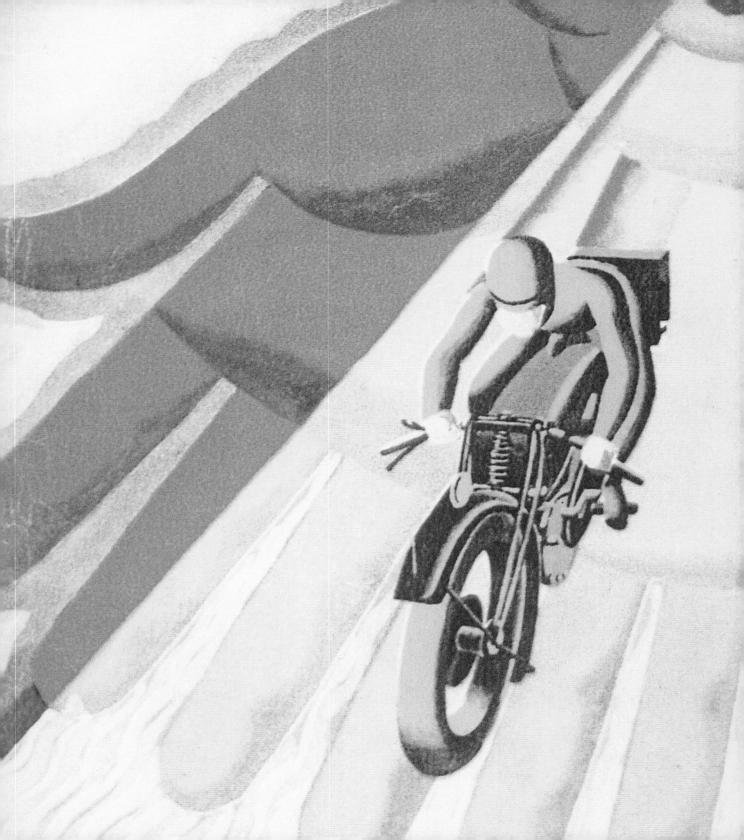

Posters

As part of the urban environment, posters exposed the public to the graphic genius of A.M. Cassandre, Edward McKnight Kauffer and Paul Colin, among others.

MOTOR CYCLES

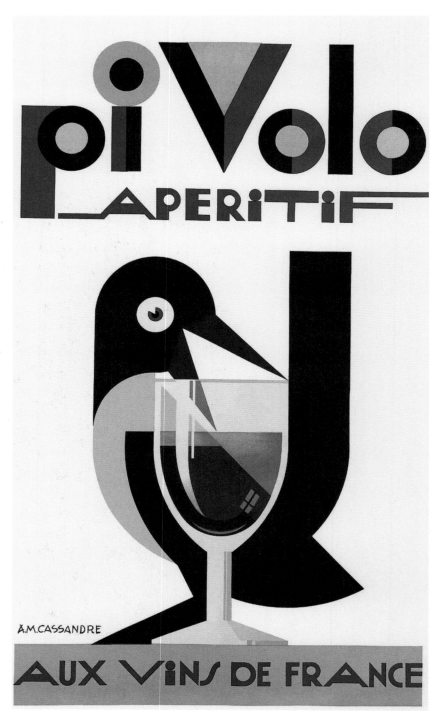

A.M. Cassandre (1901–68)
Colour print

Poster for Pivolo Apéritif, 1924 During the early stages of designing this advertisement, A.M. Cassandre realized that the pronunciation of the brand's name sounded much like the French for 'magpie flies high' ('pie vole haut'). He proceeded to realize his pun with cunning economy.

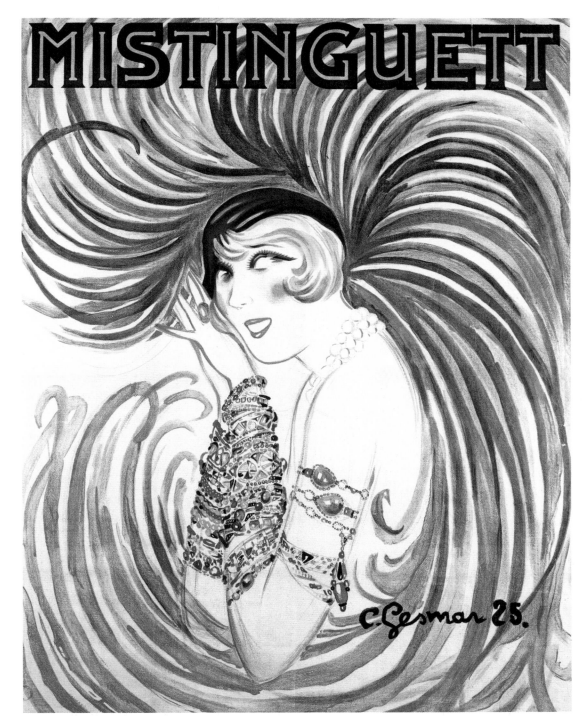

MISTINGUETT

Charles Gesmar (1900–28)
Colour print, 20.3 x 27.4 cm (8 x 10¾ in) • Musée de la Publicité, Paris

Poster for a cabaret show of Jeanne Florentine Bourgeois, 1925 Charles Gesmar was a prolific graphic artist and costume designer, whose primary patron was the cabaret performer Jeanne Florentine Bourgeois – better known as 'Mistinguett' – who, in her heyday, was the world's highest-paid female entertainer.

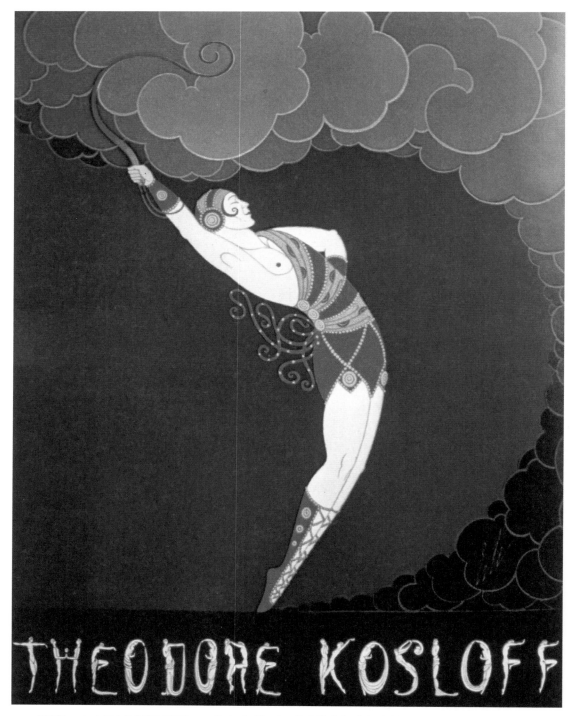

Erté (Romain de Tirtoff, 1892–1990)
Colour print

Poster for Theodore Kosloff's Ballet School, 1925 Erté promoted Kosloff's Hollywood-based ballet school with a primary image that marries Greek vase painting with Aubrey Beardsley's illustrations. However, this sleek figure is arguably outstripped by the clever anthropomorphic letterforms that spell out Kosloff's name.

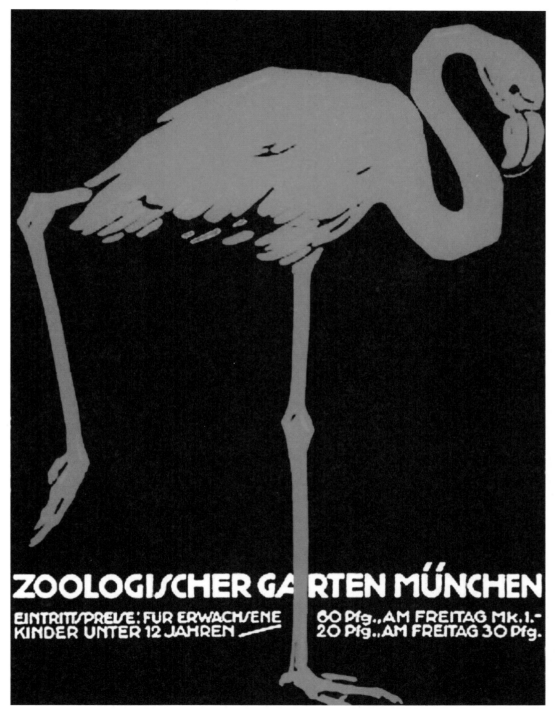

Ludwig Hohlwein (1874–1949)
Colour print

Zoo poster with a red flamingo, 1925 This arresting image for Munich's zoological garden owes much to Deutscher Werkbund aesthetics. As such, it demonstrates the real challenge that Werkbund artists, Ludwig Hohlwein among them, presented to the primacy of the French in high-quality design.

MINISTÈRE DU COMMERCE ET DE L'INDUSTRIE

PARIS·1925

EXPOSITION
INTERNATIONALE
DES ARTS DÉCORATIFS
ET INDUSTRIELS
MODERNES
AVRIL·OCTOBRE

Robert Bonfils (1886–1972)
Colour lithograph, 99 x 64 cm (39 x 25 in) • Private Collection

Poster for the 1925 Paris Expo, 1925 Its lettering harks back to an aesthetic mix that echoes graphic schemes of the American Roycrofters and the Deutscher Werkbund. However, the tautly rendered, schematic figures of a bounding woman and leaping antelope embody Style Moderne.

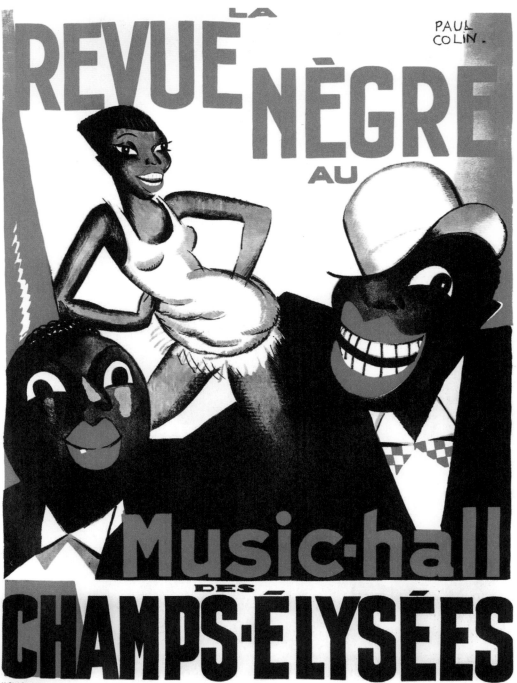

Paul Colin (1892–1985)
Colour lithograph

Poster for 'La Revue Nègre', 1925 Paul Colin's body of graphic work, produced in collaboration with, and as an homage to, Josephine Baker and her colleagues in 'La Revue Nègre', vividly evoke the excitement caused by their ground-breaking performances in various Paris nightclubs.

MON SAVON...

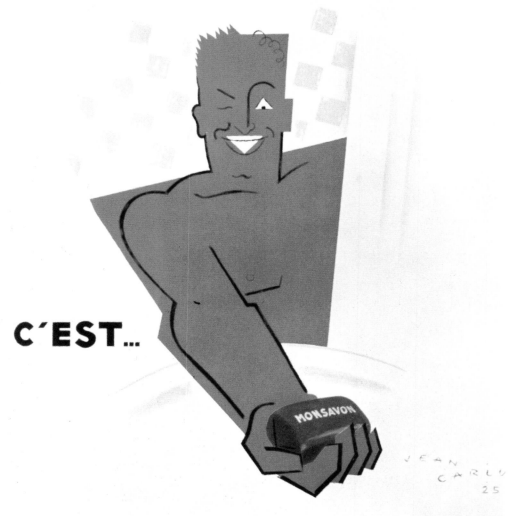

C'EST...

"MONSAVON"

Jean Carlu (1990–97)
Colour print

Monsavon soap advertisement, 1925 Jean Carlu's geometric style is well suited to this promotion for Monsavon ('my soap'). A rare representation of a sturdy, workaday man – as opposed to a preening aesthete – it emphasizes the product's potential to refresh and invigorate.

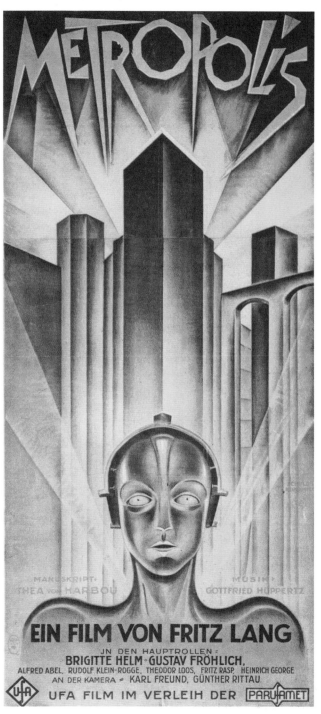

Heinz Schulz-Neudamm (1899–1969)
Colour lithograph, 92.7 x 205.7 cm (36⅔ x 81 in)

Poster for *Metropolis*, 1926 In Heinz Schulz-Neudamm's hands, the beloved skyscrapers of Art Deco modernity become symbols of dystopian inhumanity. But there is more. The foreground of this iconic German Expressionist poster is dominated by the seductive robot-surrogate for the film's heroine, Maria.

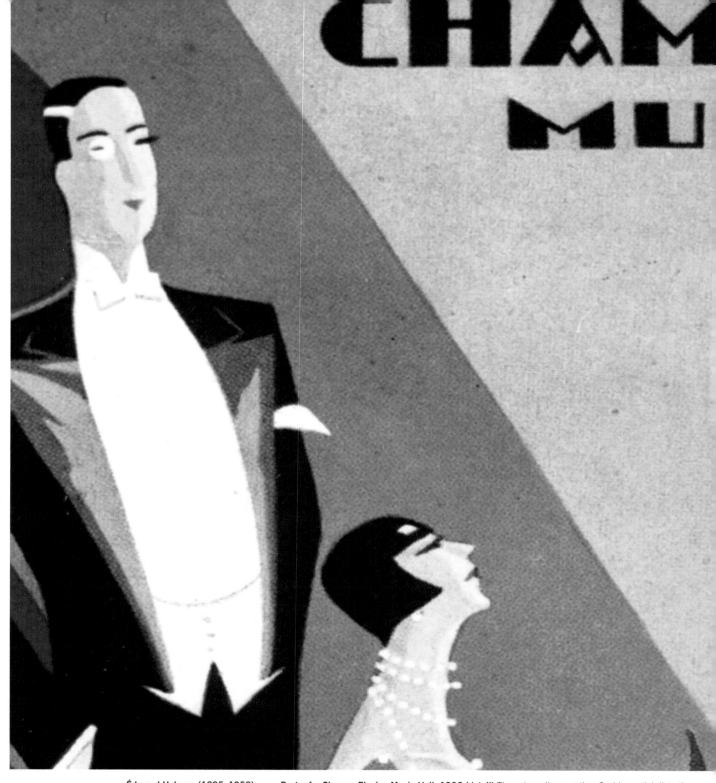

Édouard Halouze (1895–1958)
Colour print

Poster for Champs Elysées Music Hall, 1926 (detail) The extraordinary, rather Orphic spatial distortion in this image by Édouard Halouze hints that the woman with the very large fan (*see* page 6) has been transported into another dimension. It is not clear if her companion is sharing that experience.

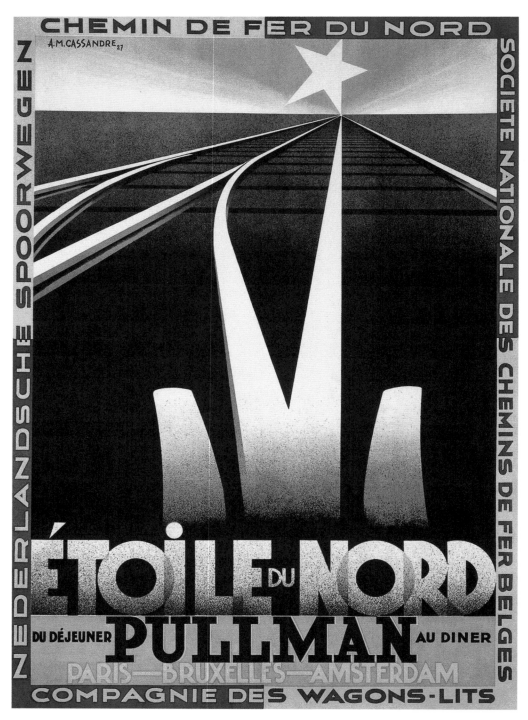

A.M. Cassandre (1901–68)
Colour print

Poster for the *Étoile du Nord*, 1927 Swift travel to distant, romantic destinations is evoked in this innovative design by A.M. Cassandre for the *Étoile du Nord* express train. Where other graphic artists might provide a picturesque view or a bathing beauty, Cassandre appeals to more abstract desires.

Jean Prunière (1901–44)
Colour print

Poster for Favor Cycles and Motos, 1927 Jean Prunière's charismatic poster for Favor bicycles and motorcycles illustrates the enthusiasm for exercise and good health that were key elements of modern life. Perhaps to mitigate the effects of all those alcohol-fuelled nights in urban clubs?

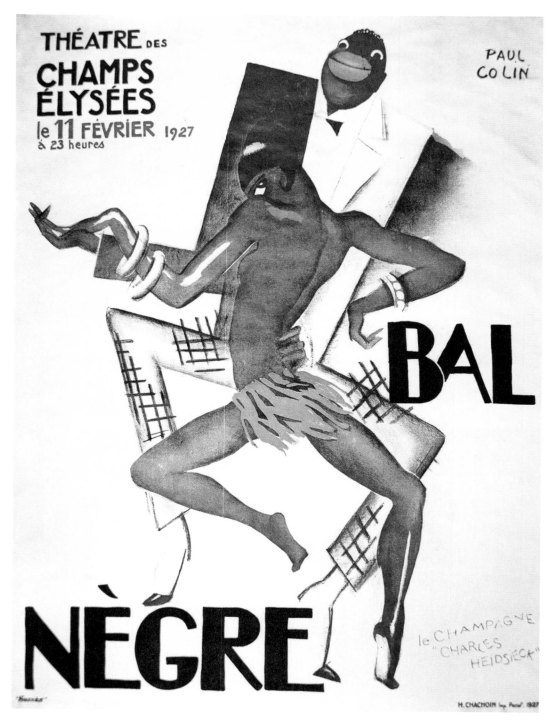

Paul Colin (1892–1985)
Colour lithograph • Private Collection

Poster for Bal Nègre, at the Champs Élysees theatre, 1927 Josephine Baker is shown dancing with a fully dressed man, looming large over her fluid figure. By this time, Baker's recognition was such that, with or without banana skirt, the curl of hair at her temple clearly signalled her identity.

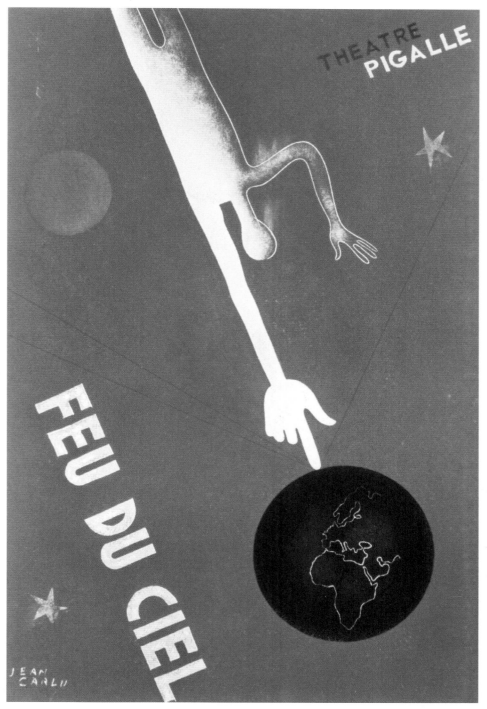

Jean Carlu (1900–97)
Colour print

Poster for Théâtre Pigalle, Paris, 1927 The machinery behind the magic of theatre is given centre stage in this poster by Jean Carlu for the Théâtre Pigalle. The Pigalle project was financed by Philippe de Rothschild to be the most technologically advanced performance space in the world.

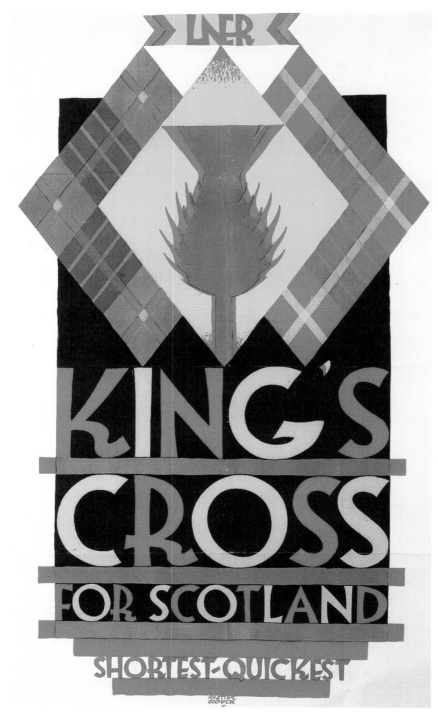

Austin Cooper (1890–1964)
Colour lithograph, 102 x 64 cm (40 x 25 in) • Private Collection

Poster for London & North Eastern Railways, 1928 Vibrant primaries plus black and white contribute to this simplified, heraldic image. This graphic palette works with symbolic allusions to Scotland – tartan-patterned diamonds flanking a thistle – to modernize a traditional approach to image-making.

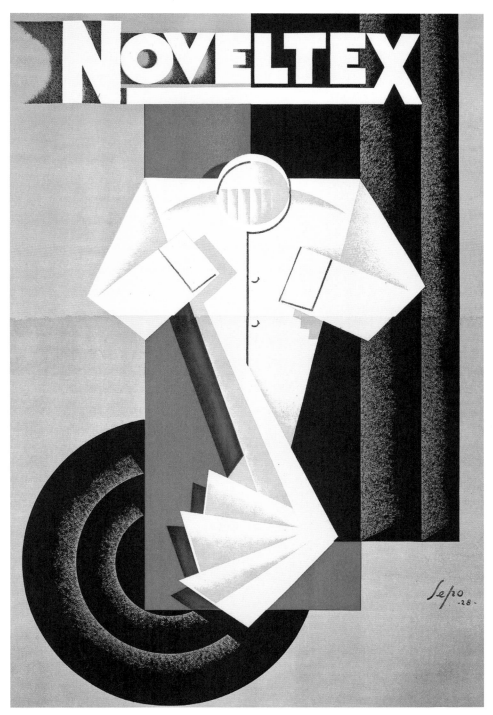

Severo (Sepo) Pozzati (1895–1983)
Colour lithograph, 202 x 139 cm (79½ x 54¾ in) • Private Collection

Poster for Noveltex, 1928 Noveltex, a French manufacturer of fine shirts and collars, employed the Italian graphic designer Severo Pozzati for more than a quarter of a century. This felicitous relationship led to the production of a long series of outstanding modern advertising images.

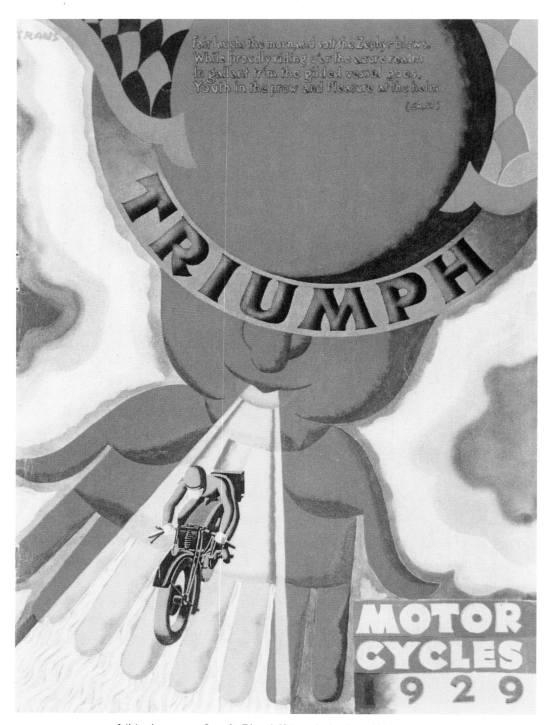

Artist unknown
Colour print, 25 x 18.3 cm (9⅘ x 7¼ in)
• National Motor Museum, Beaulieu, UK

Cover for Triumph Motorcycles brochure, 1929 A bit of Art Deco whimsy that could be verging on the surreal, this 1929 poster for Triumph motorcycles does manage to convey the pleasures of speeding along in the open air.

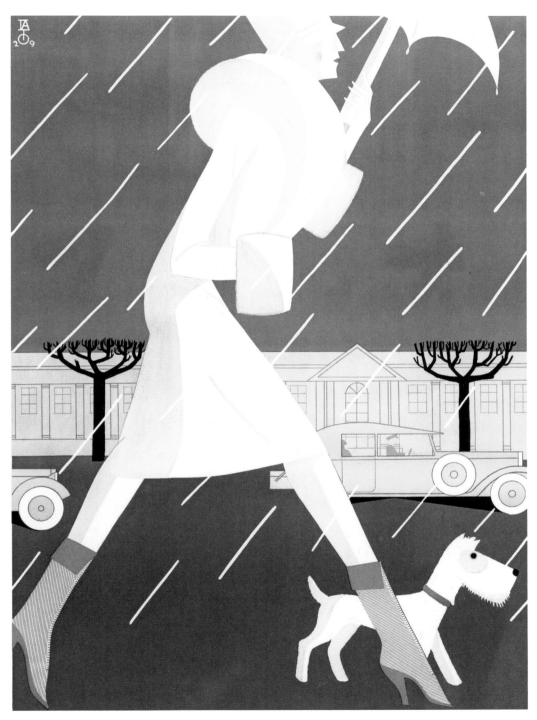

Eduardo García Benito (1891–1953)
Colour lithograph

Poster for Candee snowboots, 1929 A long, sure stride and pert Scottie, plus the luxury car in the background, support Benito's message that modern women need no more than Candee boots and a brolly to legitimize their taking a walk on a sloppy day.

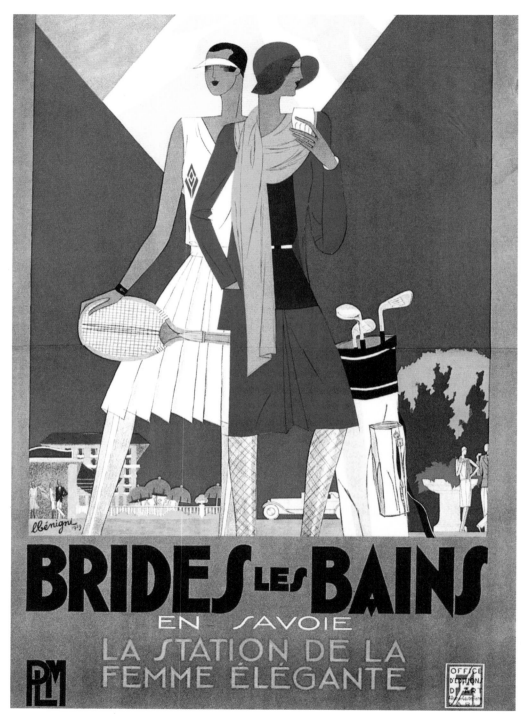

Léon Benigni (1892–1948)
Colour print

Poster for Brides-les-Bains, 1929 The French resort of Brides-les-Bains was an alpine retreat for year-round sports. The vivid colours and suitably kitted models used by Léon Benigni in this poster let independent women know it is a salubrious place for them to summer.

Vladimir Bobri (Bobritsky, 1898–1986)
Colour lithograph • Private Collection

Eye Catchers poster with a balloon vendor, 1929 This image by Vladimir Bobri – also known as Bobritsky – is remarkably playful. The dizzying perspective first presents viewers with a massive bunch of crayon-colour balloons. The figures are picked out in the same bright colours.

Leo Marfurt (1894-1977)
Colour lithograph • Private Collection

Advertisement for Belga cigarettes, 1930 Simplified shapes and a boldly minimal palette were Leo Marfurt's hallmarks. Here, however, he combined areas of unmodulated colour with subtle shading of the woman's face. Her come-hither gaze and upturned cigarette suggest she is more than approachable.

Jean Chassaing (1905–38)
Colour print

Poster for 'En bordée', *c.* **1930** Jean Chassaing's poster publicizes a music-hall revue premised on a nautical/travel theme. The image communicates streamline settings, lively sailors and the potentially fraught adventures of independent women.

ch. Loupot
30

Edition "les belles affiches" Création 1930

Charles Loupot (1892–1962)
Colour lithograph, 160 x 120 cm (63 x 47½ in) • Private Collection

Poster for Twining tea, 1930 Rather than establishing a signature style, Charles Loupot adapted his graphic approach to his client's needs and their most appropriate expression. In this promotion for Twining, the upper case 'T' serves as a cloth of honour behind the aromatic cuppa.

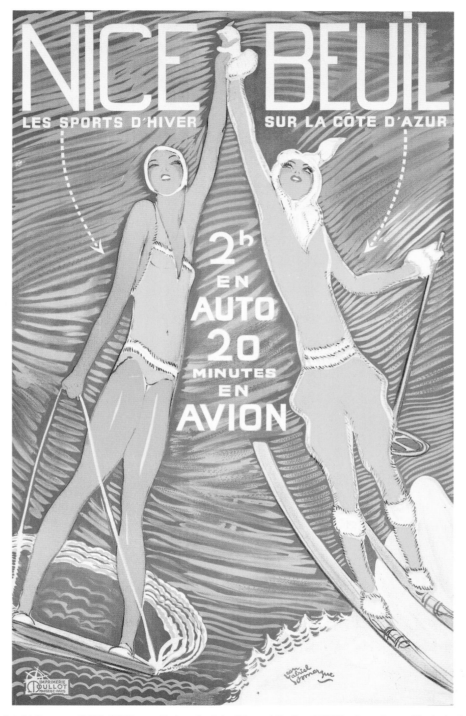

Jean-Gabriel Domergue (1889–1962)
Colour lithograph, 100 x 62 cm (39⅓ x 24⅔ in) • Private Collection

Poster advertising Nice and Beuil, *c.* 1930 Two hours by car, 20 minutes by plane. Distance between the sunny Côte d'Azur and the snowy slopes at Beuil becomes negligible in Jean-Gabriel Domergue's charming advertisement. Advances in transport opened up a whole new world of winter sports.

Orsi (1889–1947)
Colour lithograph • Private Collection

Poster for Sonora Radio, *c.* **1930** The Sonora Company's motto was that its radio sound was 'As clear as a bell'. The mysterious Orsi brilliantly consolidates this claim into an image of a ringing bell that, like a lamp, also radiates the light of clarity.

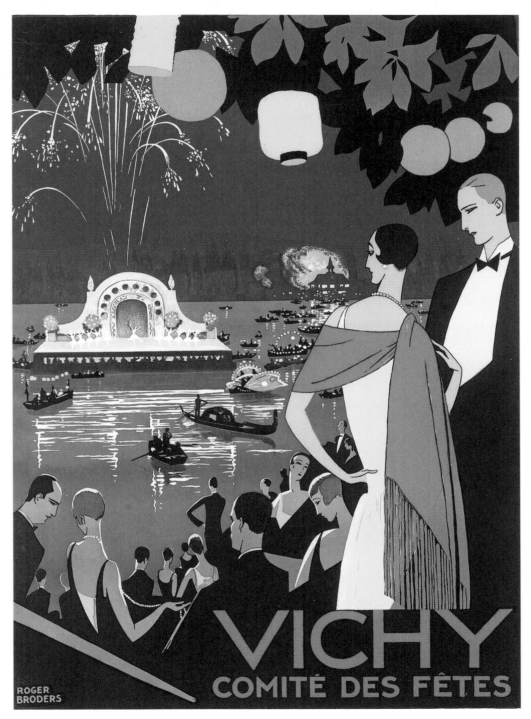

Roger Broders (1883–1953)
Colour lithograph, 107 x 78 cm (42 x 30¾ in) • Private Collection

Poster advertising Vichy, *c.* **1930** Roger Broders' travel posters promoted the Côte d'Azur, Chamonix and other resorts. This for the spa of Vichy plays upon the renown of its mineral spring – 'la source' – by promoting it as a source of multiple forms of healthful entertainment.

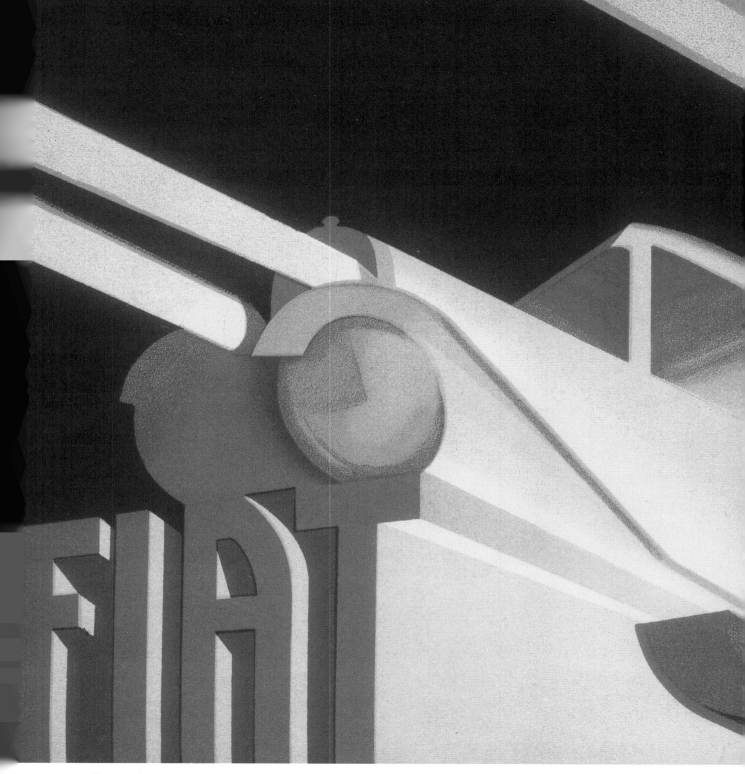

Giuseppe Riccobaldi (probably), (1887–1976)
Colour print, 21.5 x 28.5 cm (8½ x 11¼ in)
• National Motor Museum, Beaulieu, UK

Brochure cover featuring the Fiat 514, 1931 The Fiat 514 was built between 1929 and 1932, in a range of body styles from the sporty 'Spider' to the staid saloon. The graphic designer here is not certain, but it is almost certainly Giuseppe Riccobaldi, who produced work for Fiat.

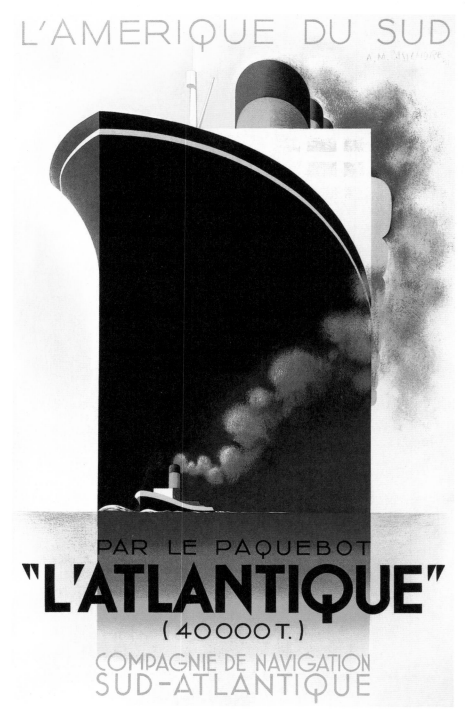

A.M. Cassandre (1901–68)
Colour print

Poster for *L'Atlantique* steamer, 1931 A.M. Cassandre's promotion for the *Normandie* might be the greatest Art Deco steamship poster – even if only because it features the *Normandie*. However, this poster for *L'Atlantique* is the quintessence of geometric audacity and the judicial use of airbrush effects.

Max Ponty (1904–72)
Colour print

Poster for Primerose cigarettes, 1931 Max Ponty makes use of verbal and visual double entendre in this dreamy poster for Primerose cigarettes. With its red, 'rose-petal tip', smoking will not show traces of a lady's rose-petal red lipstick.

Edward McKnight Kauffer (1890–1954)
Colour lithograph, 101.6 x 63.5 cm (40 x 25 in)

Poster for the London Underground, 1931 Shortly after American designer McKnight Kauffer arrived in England, London Transport executive Frank Pick hired him to promote the Underground. Pick perceived the Underground as synonymous with London – as this poster for entertainment-related travel vividly illustrates.

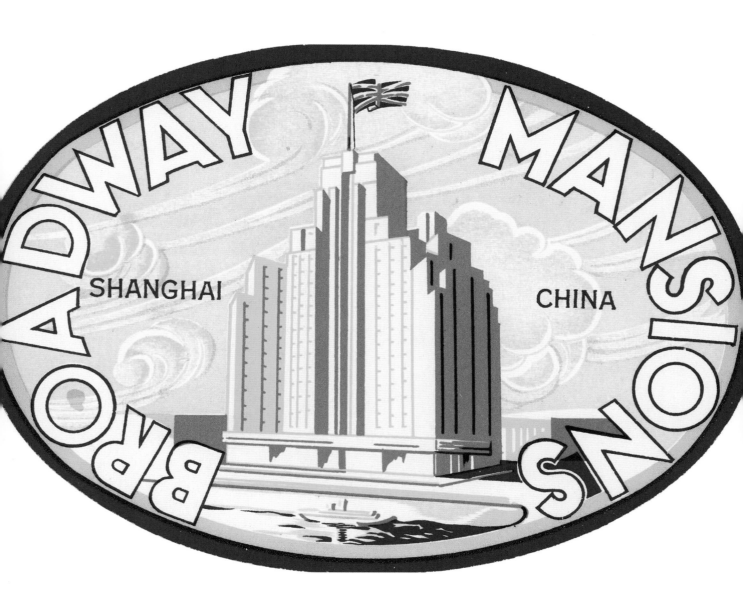

Artist unknown
Label

Luggage label from Broadway Mansions, Shanghai, *c.* 1930s As its Union Jack suggests, the Broadway Mansions were conceived of as a luxury apartment building for Shanghai-based British businessmen. That this is a luggage label makes it all the more a mark of the era.

"There's a
 Transport of Joy at the Zoo."

Camden Town, Chalk Farm or
Regents Park "Underground" Stn.

Jean Théodore Dupas (1882–1964)
Colour lithograph, 110 x 71.1 cm (43⅓ x 28 in) • Private Collection

There's a Transport of Joy at the Zoo, **poster for London Zoo, 1933** Jean Dupas
took a neoclassical approach to his subjects, and we see his characteristically elegant
simplification and elongation of figures in this depiction of 1930s London entertainment.

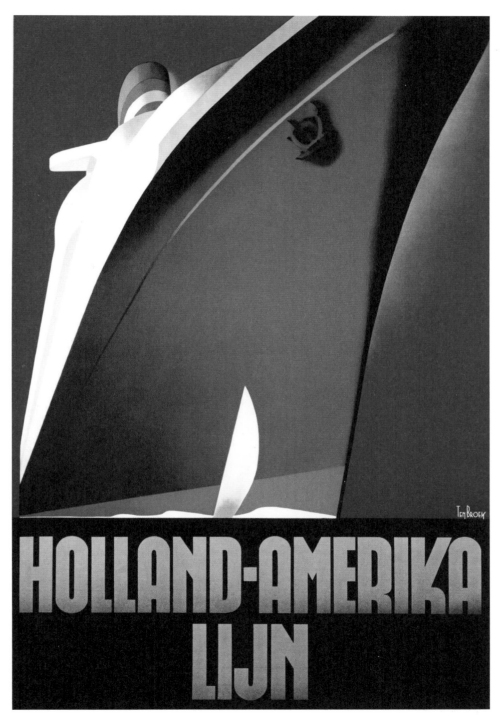

Willem Frederik Ten Broek (1905–93)
Colour lithograph, 97 x 64 cm (38 x 25 in) • Private Collection

Poster for Holland Amerika Lijn, 1936 A gleaming off-centre prow and diagonal curves that converge in an out-of-frame vanishing point shout swift, first-class transport. Interestingly, at the time of Ten Broek's poster, the Holland America Line was the chief conveyor of immigrants from Europe to the United States.

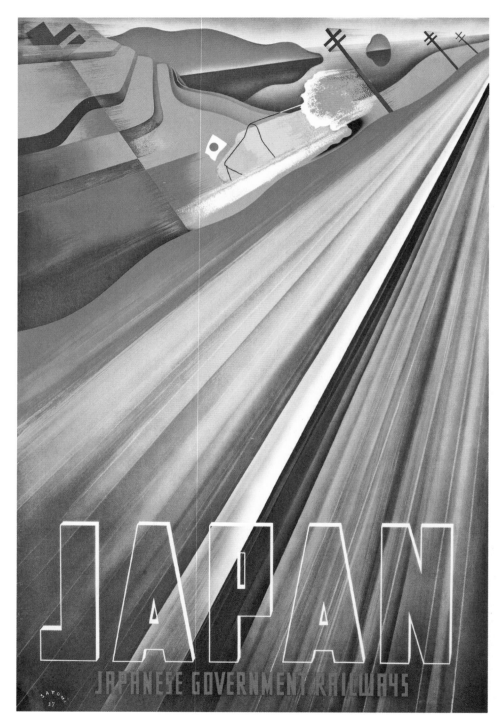

Munetsugu Satomi (1900–95)
Colour lithograph, 100 x 64 cm (39⅓ x 25 in) • Private Collection

Poster for Japanese Government Railways, 1937 Japan's rapidly expanding economy and cities required faster transit. In this image – pivoting between past and future – Munetsugu Satomi alludes to a swift train by blurring the blossoming cherry tree and scenery in its wake.

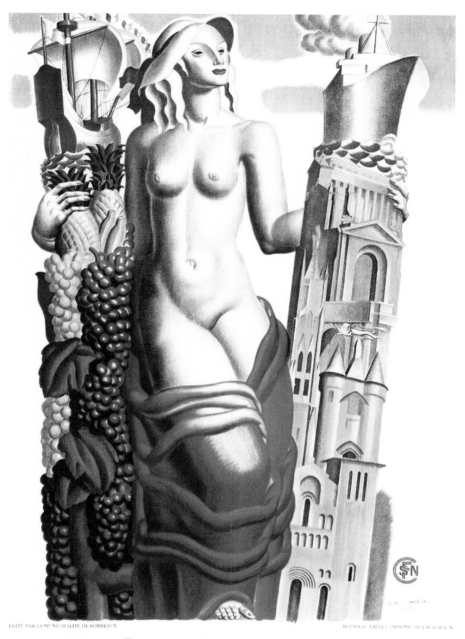

BORDEAUX
SON PORT · SES MONUMENTS · SES VINS

Jean Théodore Dupas (1882–1964)
Colour print

Poster advertising Bordeaux, 1937 Moving in an increasingly surreal direction, Jean Dupas situates a monumental woman – naked but for her broad-brimmed hat – between two columnar assemblages that allude to trade, travel and monuments. Grapes for pineapples, new ships for old. And medieval towers.

Illustrations

Gifted illustrators represented the works of couturiers and the costumes and sets of theatrical designers, and created animated lifestyle images for magazine covers.

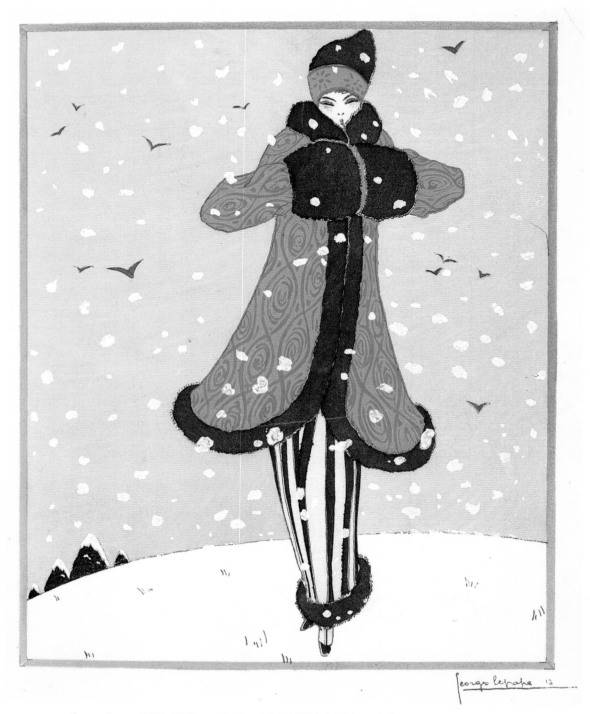

Georges Lepape (1887–1971)
Pochoir print • Private Collection

***Goodness! How Cold It Is*, 1913** Lepape's illustration for a winter coat by Paul Poiret, from the *Gazette du Bon Ton*, is wonderfully artificial, given that birds do not like to fly around in snow. However, that artifice marries well with the Style Moderne aesthetics of colour, elongated contours, taut curves and pattern.

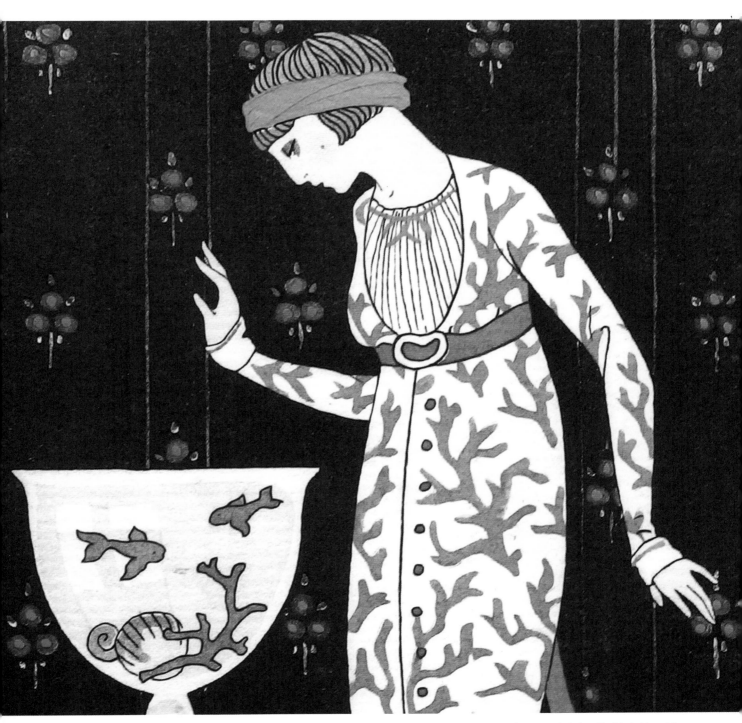

Georges Barbier (1882–1932)
Pochoir print • Private Collection

Robe d'Intérieur en Soie Brochée, **1913** A silk brocade housecoat is featured in this fashion plate from Georges Barbier's *Costumes Parisiens*. Published just before the First World War, it harks back to tradition as much as it looks ahead to the new.

Léon Bakst (1866–1924)
Pencil, watercolour, gouache and gold highlights on paper, 54.5 x 76 cm
(21½ x 30 in) • Musée des Arts Décoratifs, Paris

Set design for the ballet *Shéhérazade*, 1910 Léon Bakst's designs for the Ballets Russes underscored the lavish, folkloric aesthetic that dazzled Parisian sophisticates in the 1910s and 1920s, and became a source of inspiration for Style Moderne.

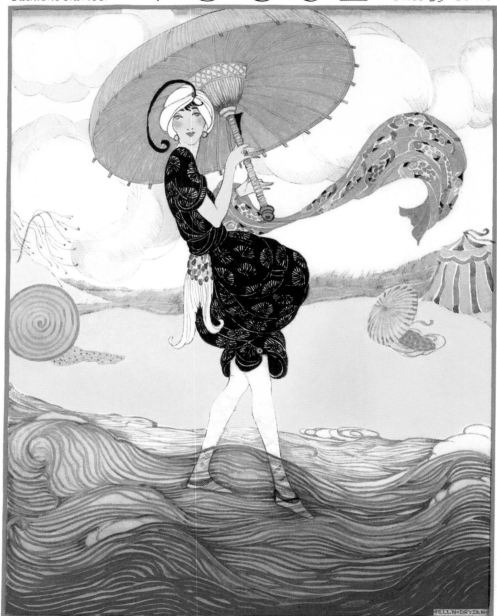

Helen Dryden (1882–1972)
Colour print

Vogue **cover, July 1919** Helen Dryden's cover for a 'Hot Weather' edition of *Vogue* is overall Oriental in its inspiration – sending the message that strolling in the surf remained an exotic way for a woman of that era to beat the heat.

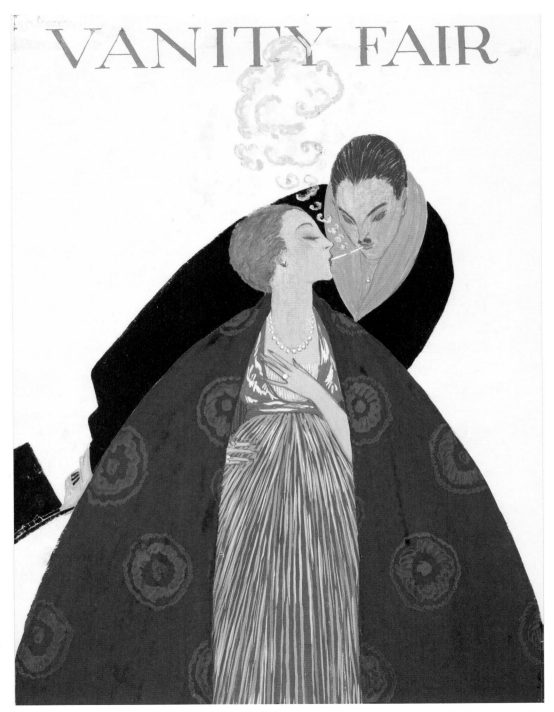

VANITY FAIR

Georges Lepape (1887–1971)
Gouache over pencil on Bristol board, 34.9 x 26.8 cm (13¾ x 10½ in)
• Library of Congress, Washington, D.C.

Design for *Vanity Fair* cover, December 1919 This illustration by Georges Lepape derives much of its charisma from the touching of cigarette tips. Who is lighting whose fire? The contrast between dynamic male figure and self-possessed, symmetrical female certainly fuels that chemistry.

Umberto Brunelleschi (1879–1949)
Colour print

Woman in feather hat, from *La Guirlande* magazine, 1919 Umberto Brunelleschi was art director of
La Guirlande. A notably rare Art Deco magazine, it blurred distinctions between fine and commercial art.
Brunelleschi also worked for the *Gazette du Bon Ton* and illustrated limited edition books.

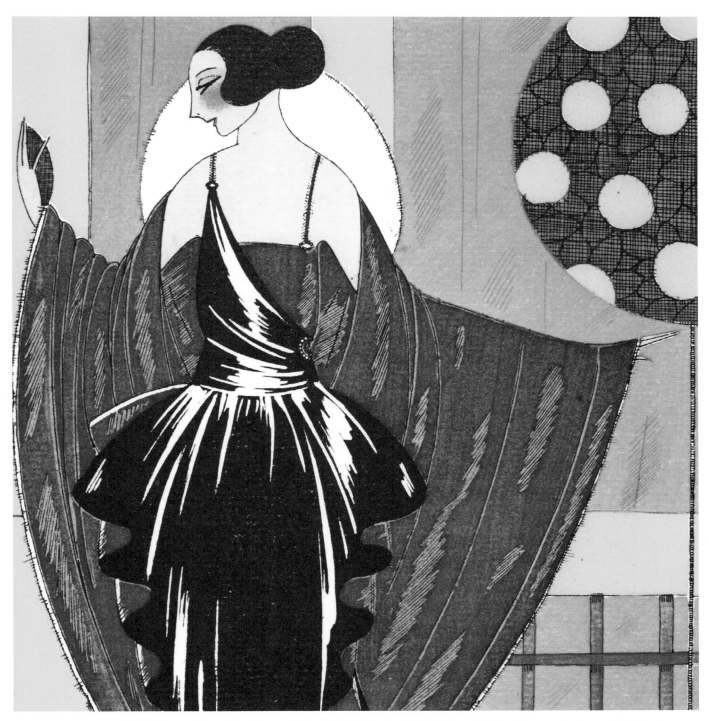

Martha Romme (dates unknown)
Pochoir print, 27.3 x 16.5 cm (10¾in x 6½ in)

Création Melnotte-Simonin, **1919–21** Before establishing his own couture house, André Melnotte-Simonin worked for Paul Poiret. In this design, attention initially focuses on the contrasting colours and textures of the two fabrics. However, a closer look reveals the incredible complexity of cut and construction.

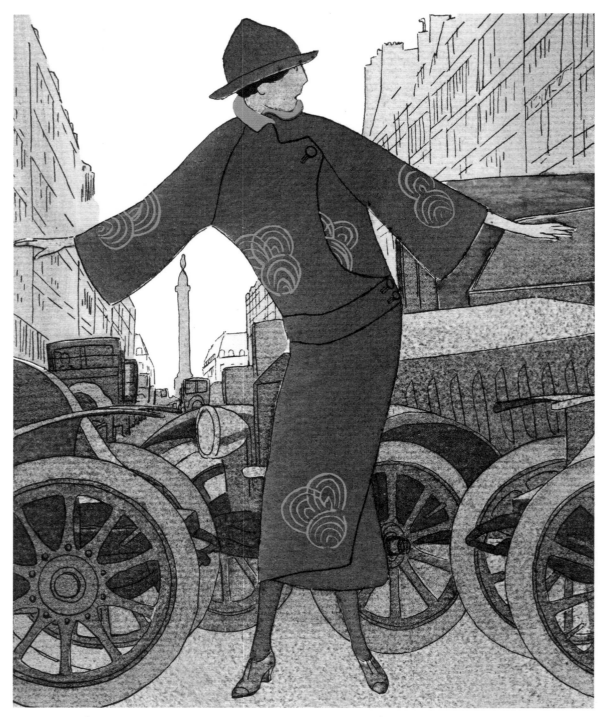

André Édouard Marty (1882–1974)
Pochoir print, 25.4 x 19.1 cm (10 x 7½ in) • Private Collection

Les Embarras de Paris, **1920** André Édouard Marty captures a woman in the midst of late-afternoon Parisian traffic. However, the chic silhouette of her overcoat, designed by Georges Doeuillet, stops cars in their tracks and will see her safely across the street.

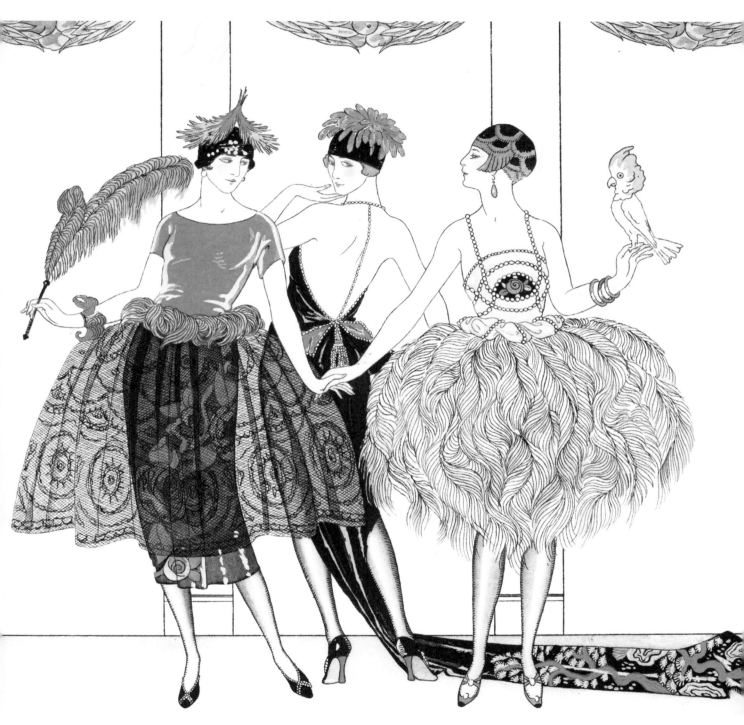

Georges Barbier (1882–1932)
Pochoir print • British Library, London

Les Belles Sauvagettes de 1920, **1920** From one of Georges Barbier's albums of modern style, this picture of 'beautiful savages' mixes machine printing and hand colouring in a process called 'pochoir'. After the image's black contours were printed, stencils were employed to ensure registration of colours.

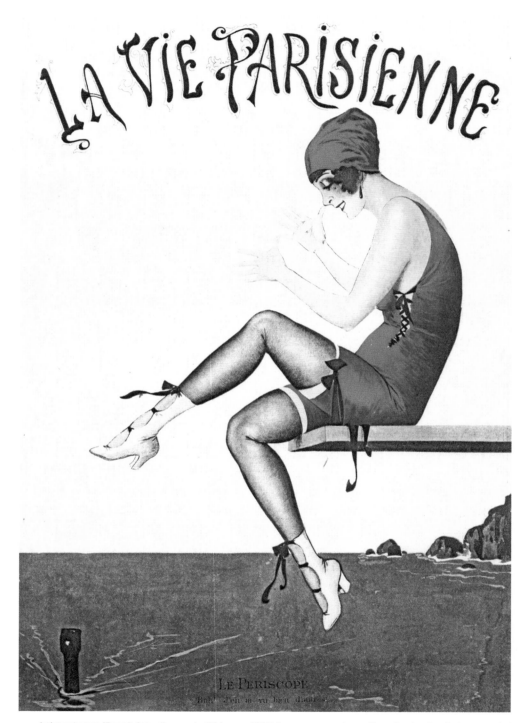

Artist unknown (French School)
Colour lithograph • Private Collection

Le Périscope, **1920** A young woman dressed for swimming thumbs her nose at whoever is at the other end of that periscope. This is the sort of sassy image that General John Pershing warned American doughboys against – thereby boosting the circulation of magazines like *La Vie Parisienne*.

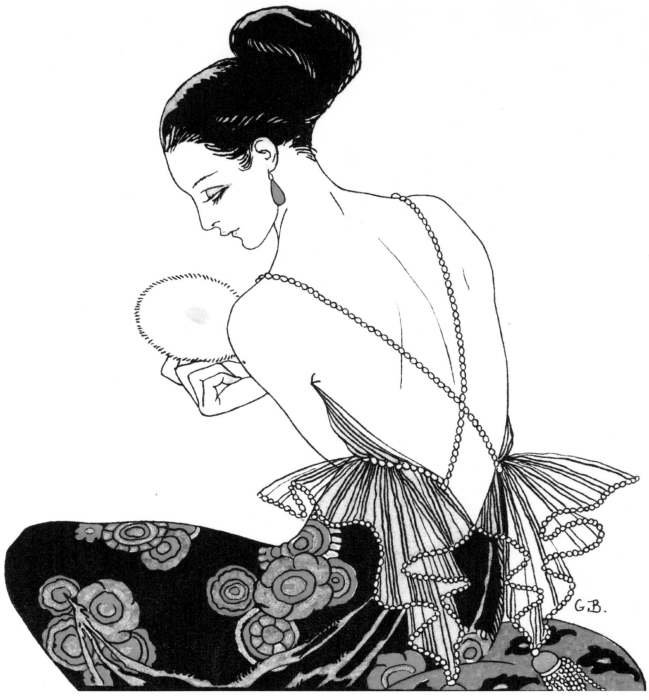

Georges Barbier (1882–1932)
Pochoir print • British Library, London

Le Bonheur du Jour, **1920** This is the cover for an album of illustrations by French illustrator and designer Georges Barbier that depicts scenes of fashionable society in Paris in the early 1920s. Each of the 16 prints in the album, as well as this cover, was produced using the pochoir technique (*see* page 107).

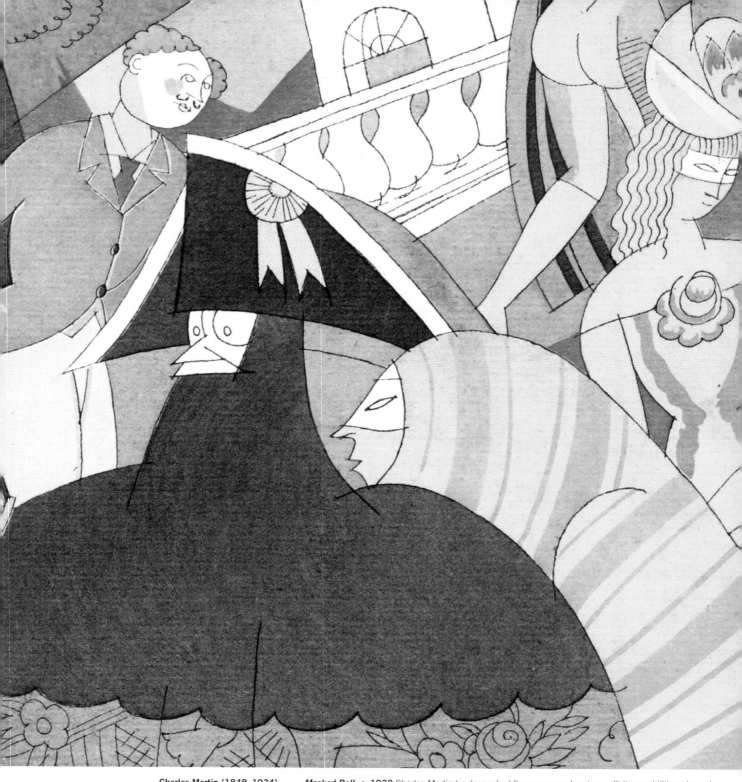

Charles Martin (1848–1934)
Stencil on paper • Private Collection

Masked Ball, c. **1920** Charles Martin treats masked figures as overlapping, colliding and tilting planes in this brilliant scene of tipsy revellers. Or is it the viewer who is inebriated? Crisp colour and economy of line enhance Martin's acerbic visual wit.

Feodor Stepanovich Rojankovsky (Rojan, 1891–1970)
Stencil on paper • Private Collection

Sledging, c. **1920** Feodor Stepanovich Rojankovsky – or 'Rojan' – used black contours and shading, and flat areas of bright colour in a complex composition influenced by Fernand Léger. A chameleon stylistically and in subject matter, Rojan illustrated erotica, fashion and children's books.

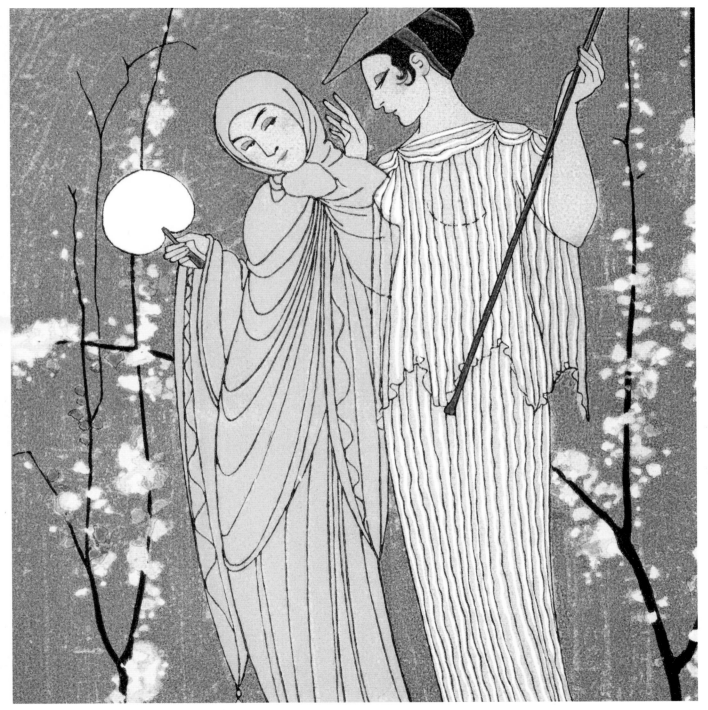

Georges Barbier (1882–1932)
Pochoir print • Private Collection

La Rencontre, 1922 In 1894, Pierre Louÿs published *Les Chansons de Bilitis*, a sensitive collection of writings that Louÿs attributed to an ancient Greek peer of Sappho. Collaborating with the wood engraver F.L. Schmied, Barbier illustrated a deluxe edition of *Bilitis* in 1922, for which this is one of the illustrations.

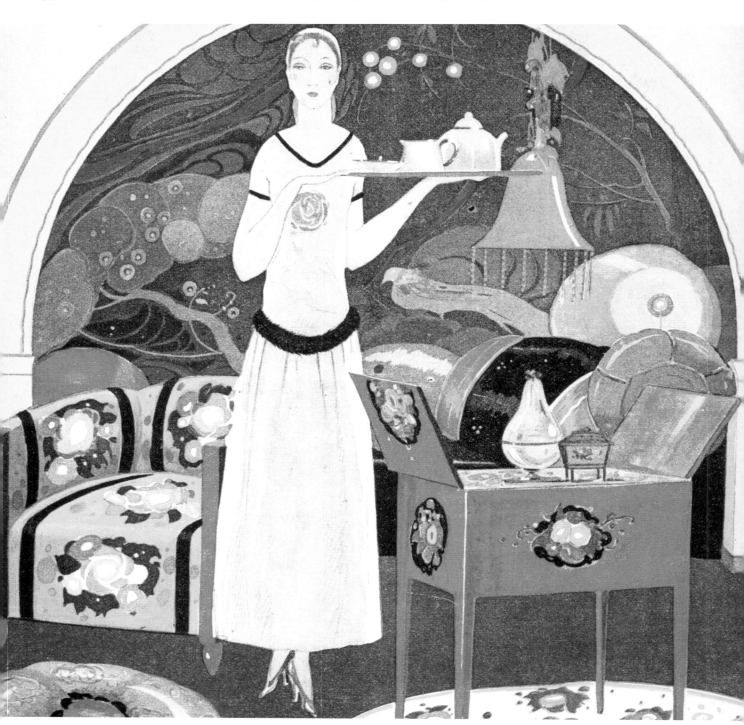

Umberto Brunelleschi (1879–1949)
Colour lithograph • Bibliothèque des Arts Décoratifs, Paris

Le Style Moderne, **1922** Umberto Brunelleschi presents a modern interior, complete with a modern hostess. She wears a comfortable dress that will permit her to move freely while serving tea to whomever enters and takes a seat in that comfy lolling chair.

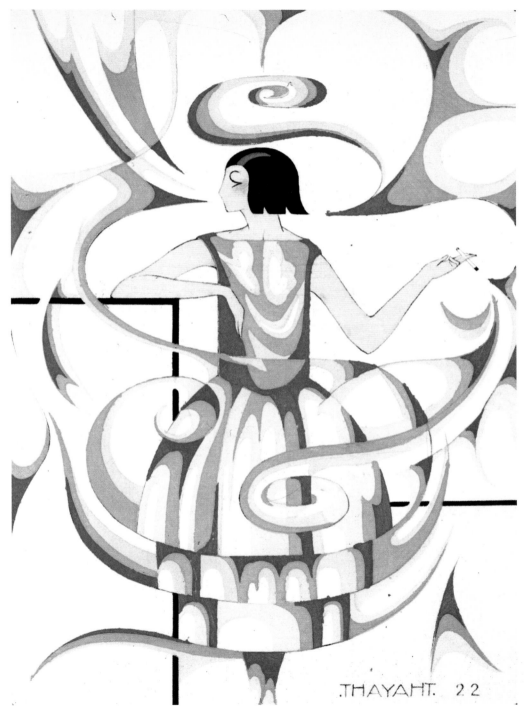

Ernesto Michahelles (Thayaht, 1893–1959)
Colour print • Private Collection

De la Fumée, 1922 Michahelles, known as 'Thayaht', has enlivened an otherwise static image, published in the *Gazette du Bon Ton*, of an evening dress by Madeleine Vionnet, who was famous for cutting fabric on a bias, creating animating drapes. Thayaht evoked this movement with swirls of smoke that refract the image.

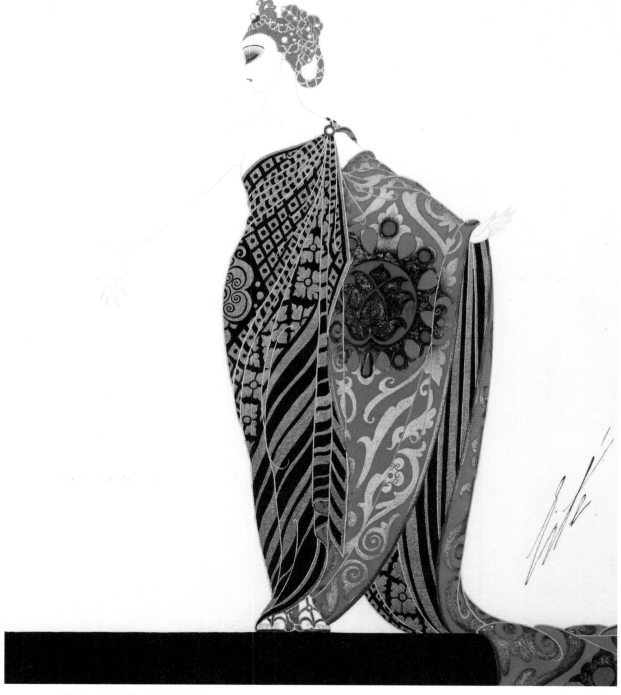

Erté (Romain de Tirtoff, 1892–1990)
Gouache and metallic paint, 31.5 x 28 cm (12⅖ x 11¼ in)
• Private Collection

Costume design for Ganna Walska, *c.* 1925 In this drawing for Ganna Walska's performance at the Folies Bergère, Erté emphasizes the drape of her heavy, richly patterned costume. Her gaze and gesture, too, communicate gravitas, perhaps ironically, as Walska was considered a mediocre singer.

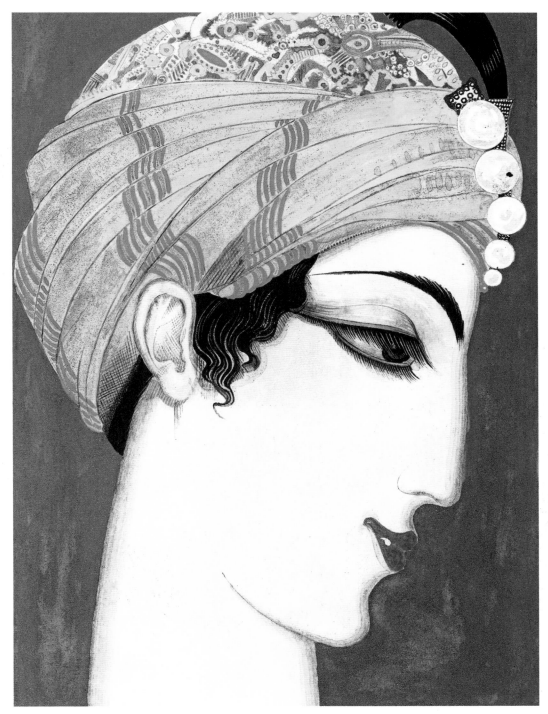

Francois-Louis Schmied (1873–1941)
Coloured print, embellished and lacquered, 27.6 x 22.8 cm (10⅞ x 9 in)
• Private Collection

Plate from *The History of the Princess Boudour*, 1926 François-Louis Schmied created this plate for a luxury edition of *The History of the Princess Boudour* – from *The Thousand and One Nights*. The story of a princess and prince of equal beauty imparts to this portrait a sensuous androgyny.

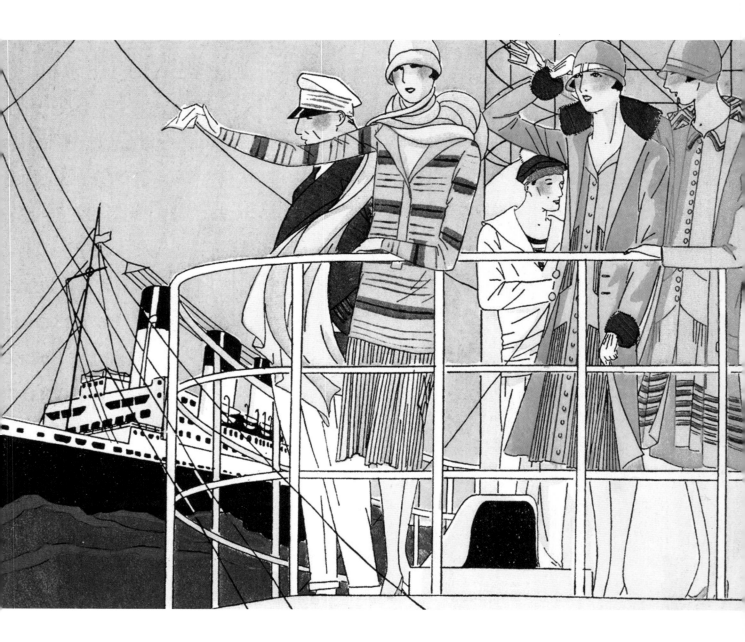

Artist unknown (French School)
Pochoir print • Bibliothèque des Arts Décoratifs, Paris

Passengers in Patou and Lelong Dresses, 1926 Because they involved hand-application of gouache, stencilled pochoir prints such as this, from the magazine *Art Goût Beauté*, were a labour-intensive and expensive means of making multiple images. But their beauty and preciousness were consistent with the ethos of Style Moderne.

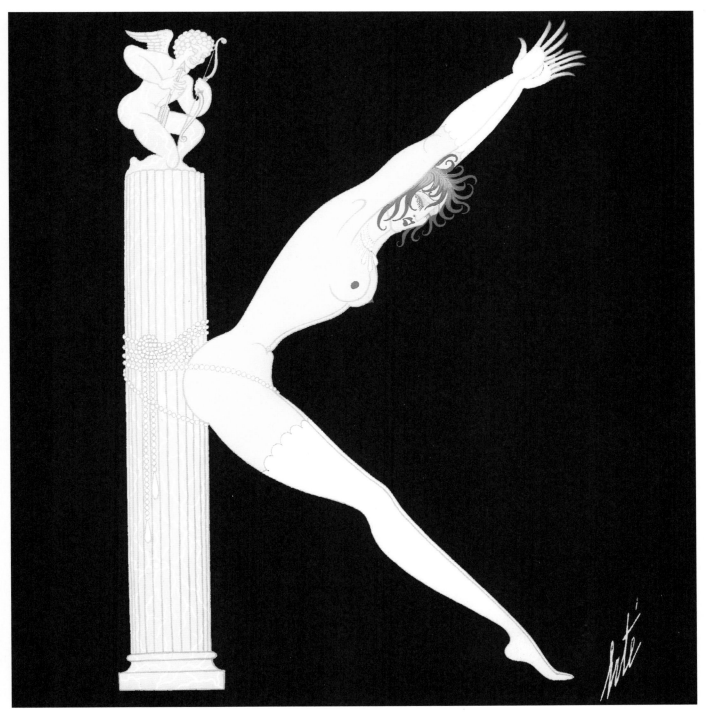

Erté (Romain de Tirtoff, 1892–1990)
Screen print, 40 x 26.6 cm (15¾ x 10½ in)
• Bibliothèque Nationale, Paris

***The Letter K*, 1927** There is more than a whiff of sadomasochism in this upper-case 'K' by Erté. It is taken from a naughty alphabet of letters imaginatively formed from sinuous men and women, as well as exotic animals.

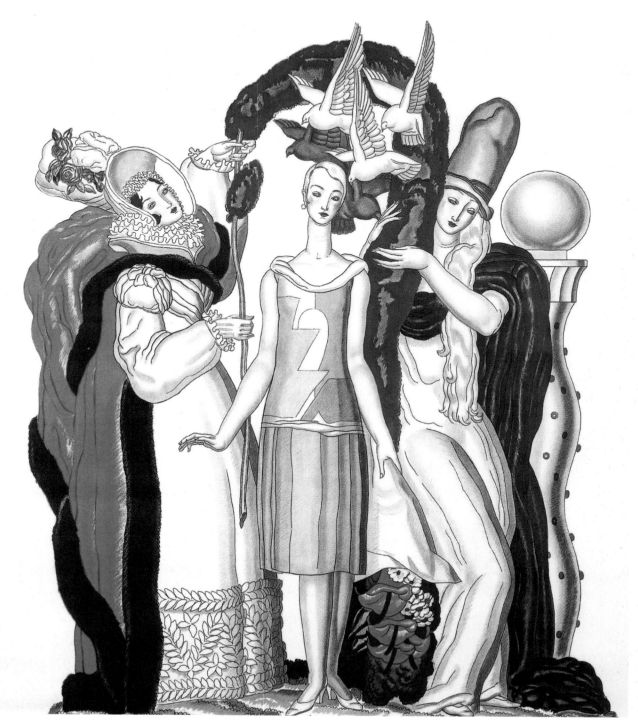

Jean Théodore Dupas (1882–1964)
Colour lithograph, 37.2 x 92.8 cm (14⅔ x 36½ in) • Private Collection

Advertisement for Arnold Constable fashions, 1928 In its heyday, Arnold Constable & Company served the Carnegies, Rockefellers, Vanderbilts and other carriage-trade clientele. By the time of this advertisement, the store had moved uptown to Fifth Avenue at 40th Street, site of a demolished Vanderbilt mansion.

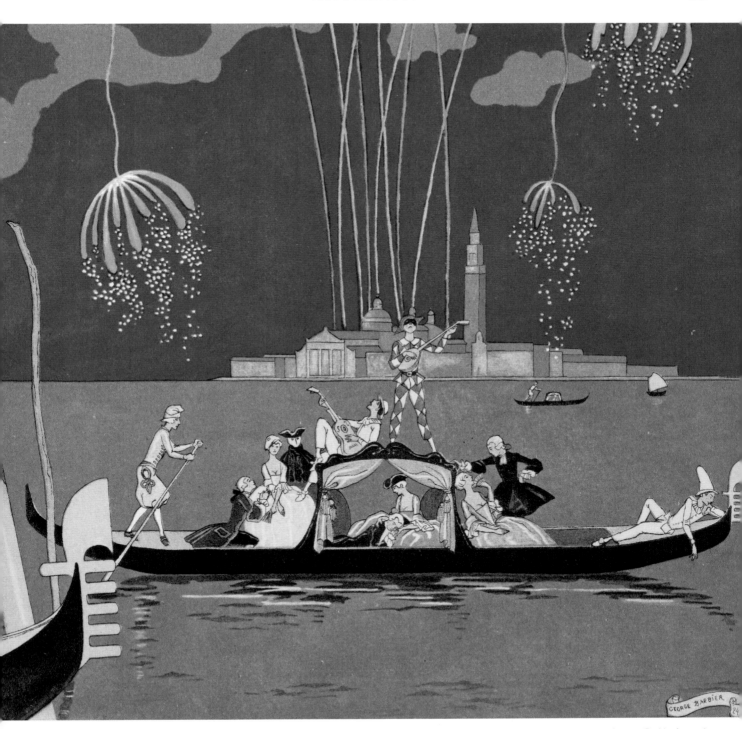

Georges Barbier (1882–1932)
Lithograph print with pochoir highlighting • British Library, London

En bâteau or *Fireworks in Venice*, 1928 For the series that included this image, Georges Barbier focused on eighteenth-century Venice. During that period, artists created pictures called 'fêtes galantes'. Celebrating risqué adventures of the aristocracy, such pictures would have resonated during the Roaring Twenties.

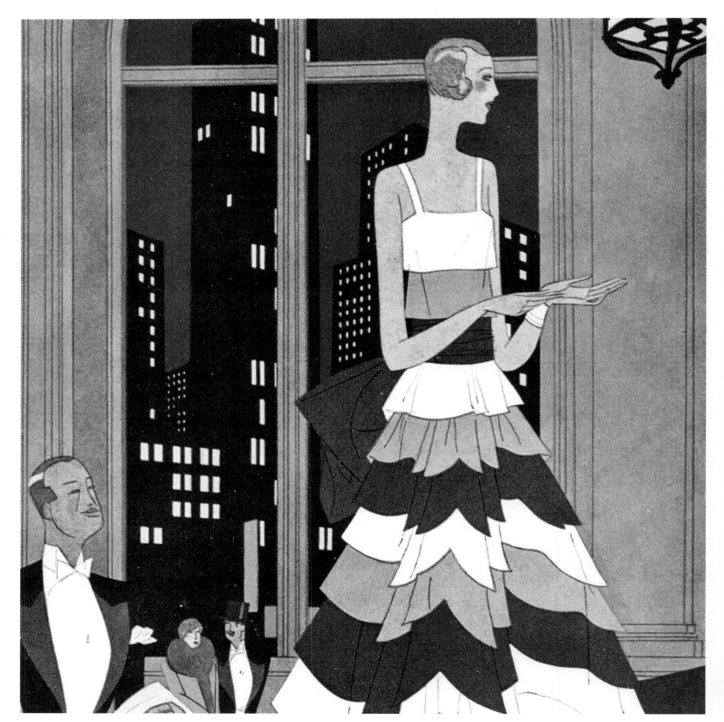

Léon Benigni (1892–1948)
Colour lithograph • Private Collection

***Under the Eyes of New York Skyscrapers*, 1928** This picture by Léon Benigni, a fashion plate from *Femina* magazine, emphasizes the public nature of the fashion statement this modern woman makes. She stands on a raised foreground, before the gaze of nearby admirers as well as the bright windows of Manhattan's skyscrapers.

Edouardo García Benito (1891–1953)
Colour print

***Early Autumn Fashions and Fashions for Children**, 1929* A supreme summation of Style Moderne, this *Vogue* magazine cover integrates Edouardo García Benito's spare illustration with artful letterforms. Benito used contours created by the boundaries between clashing colours, adding only the slightest touches of drawing.

Édouard Bénédictus (1879–1930)
Colour lithograph • Private Collection

Graphic wallpaper print, design from *Relais* series, 1930 There is nothing of the serene garden in the riotous colours and pattern of this wallpaper. Instead, the dark-and-light contrasts and hard edges impart to these tulips a sense of a bustling city street at night.

Paul Iribe (1883–1935)
Colour lithograph • Private Collection

***The Witness*, caricature of Marianne, cover of *Parlons Français*, 1934** This edition of *Parlons Français* features a portrait by Paul Iribe of his then-lover, Coco Chanel. However, it is more than a portrait. It also depicts Marianne, the symbol of France, much as Britannia personifies the United Kingdom.

Indexes

Index of Works

Page numbers in *italics* indicate illustration captions.

General Index

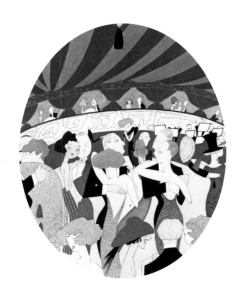

Masterpieces of Art
FLAME TREE PUBLISHING

A new series of carefully curated print and digital books covering the world's greatest art, artists and art movements.